CHRIST *for* ALL PEOPLE

Christ for All People
First published 2001

© Asian Christian Art Association, 2001

Published by:
Pace Publishing
P.O. Box 15774
Auckland 1007
New Zealand
ISBN: 0-9583632-2-6

On behalf of:
The Asian Christian Art Association
Perum Duta Wacana No. 2 Jatimulyo
Yogyakarta, 55242
Indonesia

Published in Europe by:
WCC Publications
World Council of Churches
150 route de Ferney
1211 Geneva 2
Switzerland
ISBN: 2-8254-1339-9

Published in the USA by:
Orbis Books
P.O. Box 308
Maryknoll
New York 10545-0308
United States of America
ISBN: 1-57075-378-4

Published in Canada by:
Novalis
49 Front Street East
2nd Floor
Toronto, ON M5E 1B3
Canada
ISBN: 2-89507-192-6

Cataloging-in-publication Data is available from the Library of Congress and from the National Library of Canada.

Scripture quotations are from the New Revised Standard Version of the Bible, © 1989 by the Division of Christian Education of the National Council of the Churches of Christ in the USA. Used by permission. All rights reserved.

Cover Design: Roberta Savage
Printed by Clearcut Printing, Hong Kong

CHRIST *for* ALL PEOPLE

Celebrating a World of Christian Art

Edited by
Ron O'Grady

PACE PUBLISHING
Auckland
New Zealand

ORBIS BOOKS
Maryknoll
United States

NOVALIS
Toronto
Canada

WCC PUBLICATIONS
Geneva
Switzerland

CONTENTS

IN APPRECIATION

The original idea for this book came from WCC Publications, the publishing division of the World Council of Churches (WCC). After the success of an earlier book published by the Asian Christian Art Association called *The Bible Through Asian Eyes,* the WCC felt that a similar publication to cover the whole world would be well received. The two enthusiasts for this were Jan Kok and Marlin van Elderen. Sadly, Marlin died unexpectedly in June 2000 and never saw the realization of his dream. This book is a memorial to his vision.

An editorial committee comprising Dr Judo Poerwowidagdo of Indonesia, Dr Masao Takenaka of Japan, Rev Dr John Render of the United States and associate editor Alison O'Grady met in Hong Kong in order to make a first assessment of dozens of possible art works and set guidelines for selection of additional works. Continuing support from committee members has kept the whole project on track.

A publication of this kind cannot be undertaken without cooperation from a great number of people, particularly the artists and writers who are listed at the back. Special thanks to Missio in Aachen, Pro Civitate Christiana in Assisi, the Passionist Research Center in Chicago and the Vatican Gallery of Contemporary Christian Art who willingly shared their art resources.

Our thanks also to the three mission agencies who recognized the need for this publication and gave funding to cover initial research and preparation of the materials: The Council for World Mission in the United Kingdom, The Netherlands Missionary Council and the Division of Overseas Ministries of the Christian Church (Disciples) United States of America.

Finally, thanks to the co-publishers of the book: WCC Publications in Geneva, Orbis Books in New York and Novalis in Canada, who have maintained their enthusiasm for the project and offered invaluable ideas and suggestions.

It was an inspiration to put this book together. It grew to be a spiritual journey for me. I trust it will be the same for readers.

Ron O'Grady
Editor-in Chief

INTRODUCTION

Through the centuries, Christians have been inspired in their life of prayer and devotion by works of Christian art. Many of these, such as the icons of Rublev, the sculptures and frescos of Michelangelo, or the paintings by Rembrandt, have found their place in the cultural heritage of humankind.

The biblical story, and in particular the person and life of Jesus, have continued to invite new responses in artistic form. In our time, fresh interpretations have emerged, particularly in cultural contexts beyond historical Christianity. For the last twenty-two years, the Asian Christian Art Association has been a pioneer in developing an ecumenical consciousness of the significance of Christian art.

In 1991, on the occasion of its assembly in Canberra, the World Council of Churches (WCC) was involved in the publishing and launching of their volume *The Bible Through Asian Eyes*. This has become a source of inspiration to churches and Christian people around the world, opening their eyes to the creative work being done by artists from many countries.

The present book, also prepared under the auspices of the Asian Christian Art Association, builds on the broad and positive response to the earlier publication.

As the title *Christ for All People* suggests, its scope embraces all regions of the world. Beginning with a brief section covering the most important phases of Christian art during earlier centuries, it then follows the significant features of the gospel accounts of the life of Jesus from his birth to ·his resurrection. A number of the art reproductions are accompanied by a meditation, making this a resource both for personal devotion and for educational purposes.

In his apostolic letter *Novo Millennio Ineunte* at the opening of the new millennium, Pope John Paul II offered a very rich meditation on the face of Christ. This book reinforces the invitation to contemplate the human face of God in Christ, indeed, to discover the many faces of Christ. Christian iconography has always taken seriously the affirmation of the creed that in Christ we encounter God in human form. This collection, therefore, represents a lively interpretation of the christological basis of the WCC in the language of Christian art.

The personal encounter with Jesus Christ evoked different responses already during his lifetime; from the disciples Peter and Thomas and the Samaritan woman to the Roman centurion under the cross. This book is a vivid reminder that Christian believers from every generation and from all cultures are being led to express their own confession of Christ.

The title of this collection does not intend to make a triumphalist claim. It is rather meant as a recognition that - in the words of the WCC's assembly in Nairobi in 1975 - "Jesus Christ does not make copies; he makes originals". The universality of Christ is, at the same time, the origin of the multiplicity of faces and confessions.

One of the founders of the Asian Christian Art Association, Masao Takenaka of Japan, has written: "Communication through art transcends national and linguistic boundaries. It unites people around the world beyond the differences of denominations or even ideologies. It invites people to respond to the prayers of Christ 'that all may be one'."

The WCC is glad to be a partner in publishing this new collection of Christian art which is such a moving invitation to turn to Christ, the source of our unity. Our sincere thanks go to all who have contributed to this volume and, in particular, to Ron O'Grady who has served as editor. May this publication encounter the same positive and lively reception as the earlier one ten years ago.

- Konrad Raiser
General Secretary
World Council of Churches

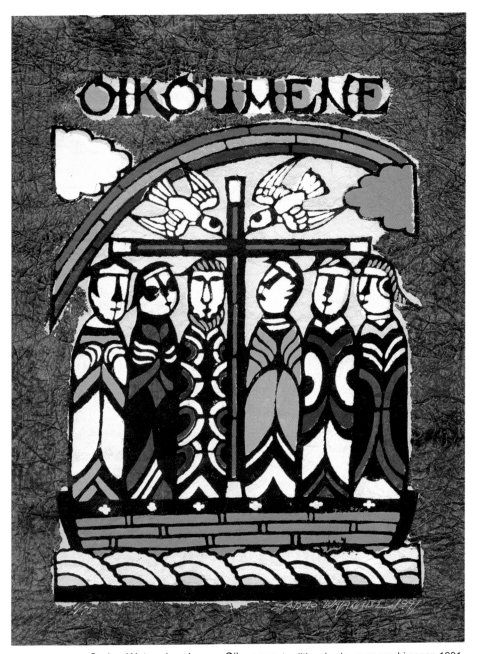

Sadao Watanabe, Japan, *Oikumene*, traditional colours on washi paper, 1991

The logo of the ecumenical movement is a small boat riding the rough seas. Japanese artist Sadao Watanabe was asked to paint a contemporary image of the ecumenical boat. Developing the theme of Noah's ark he introduced the rainbow of hope and the doves of peace above the symbolic representatives of six continents.

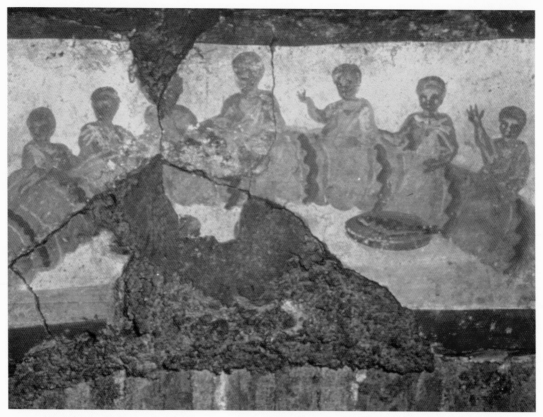

The Eucharistic Banquet, 3rd century fresco, Catacomb of San Calixto, Rome

THE BEGINNING OF CHRISTIAN ART

The first centuries of the church saw the birth of a distinctive Christian iconography, with the walls of Roman burial chambers - the catacombs - providing a canvas for the earliest Christian artists. A spontaneous art flourished. The themes usually portrayed a faith that could overcome suffering and death, such as the Old Testament stories of Noah's escape from the flood and Jonah's deliverance from the whale.

The church experienced waves of persecution, depending on the whim of the Emperor, and at such times Christians in Rome found security in the catacombs among the burial vaults.

Soon the walls were covered with new and distinctively Christian symbols. The sign of the fish, the Greek letters Alpha and Omega and Chi Rho as symbols for Christ all date from this period.

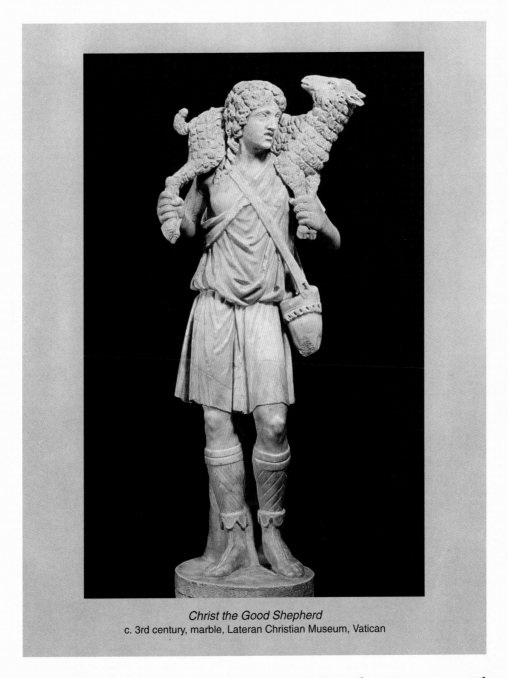

Christ the Good Shepherd
c. 3rd century, marble, Lateran Christian Museum, Vatican

Roman classical art was adapted to symbolize Christ's message. This was a natural transition but it also served a practical purpose when the church began to face persecution. The Roman god Orpheus portrayed as caring for animals could easily be used as a model for Jesus the good shepherd. Inter-laced vines, the symbol of Bacchus, god of fertility and wine, would remind Christians of Christ who described himself as "the true vine".

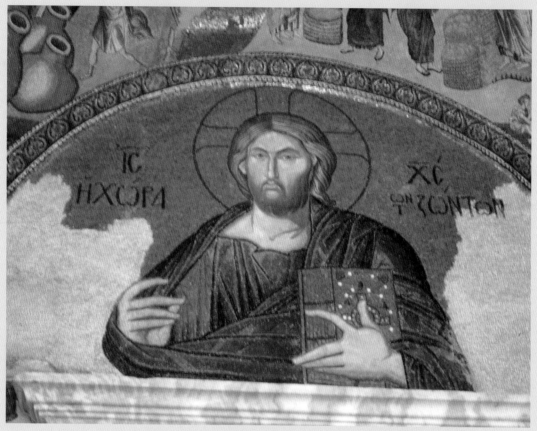

Christ Pantocrator, mosaic in the narthex, Church of St Saviour of the Chora, Kariye Camii, Istanbul, Turkey

After Constantine became ruler of Rome, he issued an edict in 313 A.D. to give official recognition to the Christians. Overnight, the church changed from being a persecuted group to become a respectable and acceptable religious community in the Roman empire.

In this new situation, the image of Jesus as the good shepherd sustaining his people in times of suffering was gradually replaced by the image of Christ as a figure of power: king of kings and lord of lords. As new churches sprang up throughout the empire they gave central prominence to Christ as the ruler of all - the Pantocrator.

Christian artists welcomed their new freedom and began to experiment with different forms of media. When the center of Western Christianity moved to Ravenna in Northern Italy, generous Imperial grants provided funding which enabled artists to create masterpieces of mosaic in the churches.

Straight walls shone like mirrors as they reflected shimmering lights to convey the transcendental nature of religious truth.

The light is either born here or, imprisoned, reigns here in freedom.

Inscription at chapel entrance, Ravenna

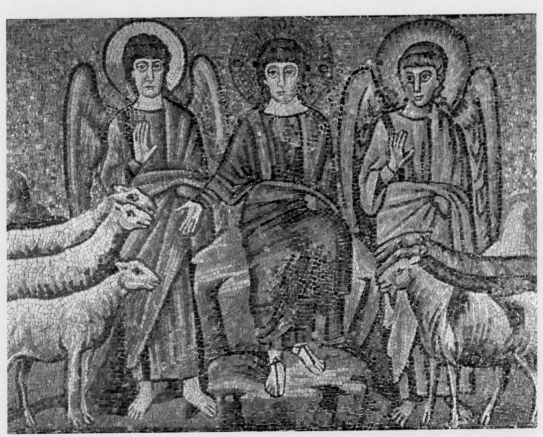

Christ Separates the Sheep from the Goats
6th century mosaic, St Apollinare Nuovo, Ravenna, Italy

13

THE ICON

A significant new art form emerged some time around the 4th century. Small panel-painted icons of Christ, Mary or the saints started to appear and by the 6th century were to be found wherever there were churches.

Not everyone approved of their use. A powerful attack by Emperor Leo in the 8th century led to the removal of all icons from public places and the persecution of those who possessed them.

The debate which followed helped to re-define a Christian understanding of pagan idolatry and the place of Christian images in the church.

John of Damascus argued that while God may not be portrayed in the form of an image, Christ became man and must therefore be depicted as a man. Icons, he said, are like shadows reflecting an invisible world that makes explicit the innate holiness of the material world.

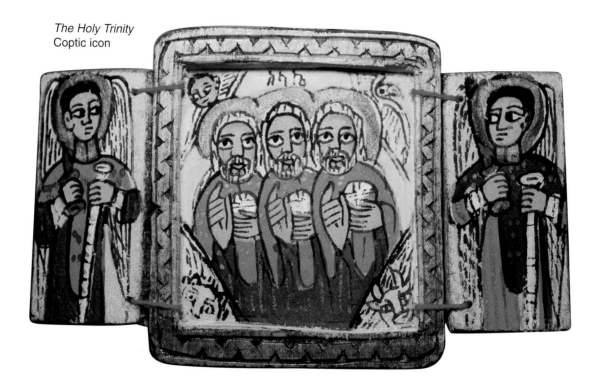

The Holy Trinity
Coptic icon

"*The indefinable has become definable
and refashioned the image of God to its former state
and has filled it with divine beauty.*"
Closing prayer at the Seventh Ecumenical Council in Nicea, 787
when it was announced that Christian icons are theologically correct.

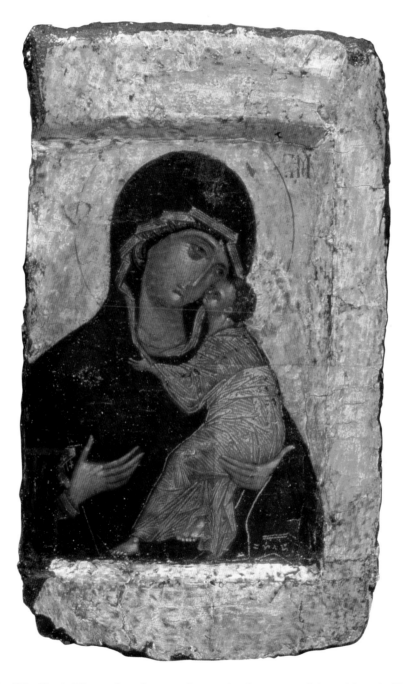

The Vladimir Virgin has been a favourite iconographic subject in Russia
since it was first painted by an anonymous Greek artist in the 12th century.
The Vladimir Madonna and Child (above) was painted by the
School of Andrei Rublev in the 15th century.

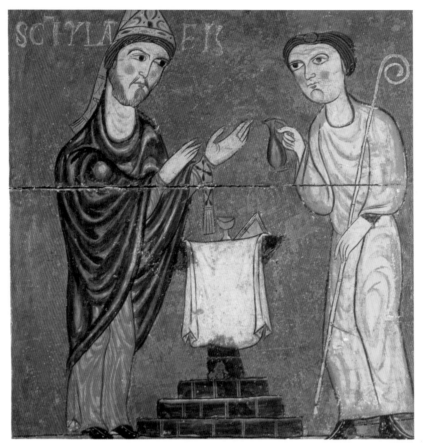

The Eucharistic Celebration, San Hilario de Vidra Church, 13th century, Episcopal Museum of Vic, Osona, Catalonia, Spain

■ MONASTERIES ■

Between 400 and 700 A.D. Western Europe was overrun by barbarians from Central Asia who laid waste to much of the cultural heritage of the Roman empire. In their struggle to survive, Christians turned inward. Many fled to the isolation of Syria, Egypt or Ireland where monasteries kept the faith alive through a strict regime of prayer and worship.

Monks were almost the only people who could read and write during those years and they preserved Christianity by long hours of writing and illuminating manuscripts of striking beauty. Of the many books still remaining, the best known is the Book of Kells printed on vellum around the 8th century.

Opposite: *Christ wih Four Angels* from the Book of Kells

16

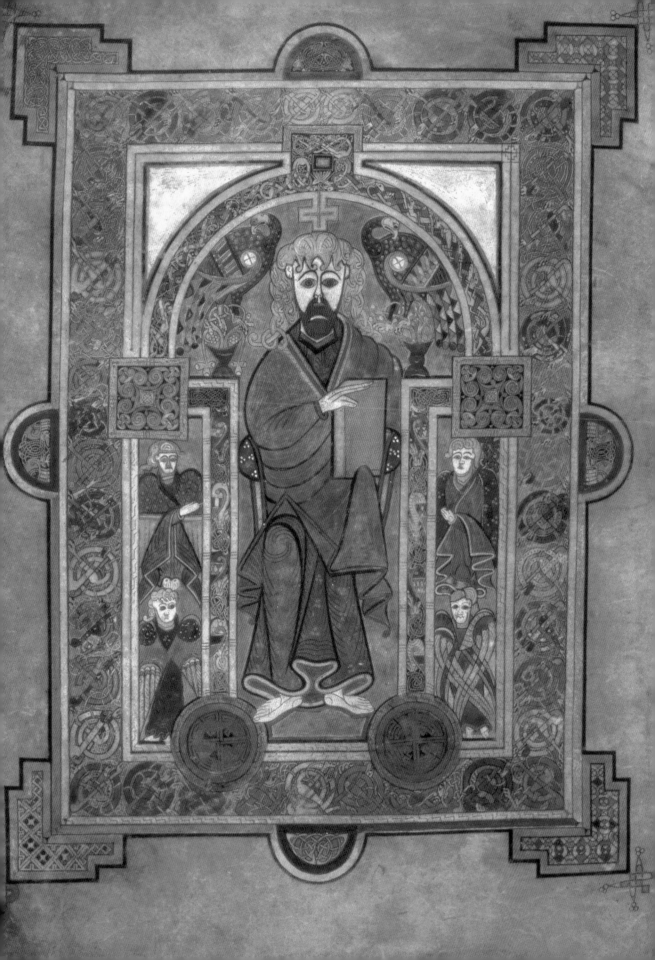

The impact of the invaders declined in the Middle Ages allowing popular religion to flourish. Christian art works were seen everywhere with shrines erected on street corners and beside bridges. Portable icons were found in most Christian homes.

A new image of Christ on the cross began to appear in these years. Known as the crucifix, it suited the changing patterns of worship in which people knelt at the altar in prayer. Now they could kneel at the feet of the crucified Christ.

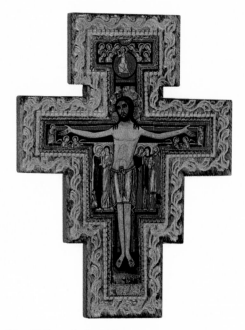

The St Francis Crucifix

Francis of Assisi became the people's saint. Around 1208 he knelt before a crucifix and heard the voice of Christ calling him to a life of poverty.

Lord,
make me an instrument of your peace.
Where there is hatred, let me sow love;
where there is injury, pardon;
where there is doubt, faith;
where there is despair, hope;
where there is darkness, light;
where there is sadness, joy.

- From the prayer of St Francis

The Middle Ages saw the emergence of a new style of architecture called Gothic which enabled large churches to be built with great soaring arches. The drive to build ever larger churches swept through Europe. In that region alone more than 80 Cathedrals and 500 major churches were built during the space of 300 years.

The strong structure of the new buildings enabled magnificent stained glass windows to be built. People who were unable to read had the opportunity to learn biblical stories from the images in the windows.

Opposite: The Rose Window, Chartres Cathedral, France

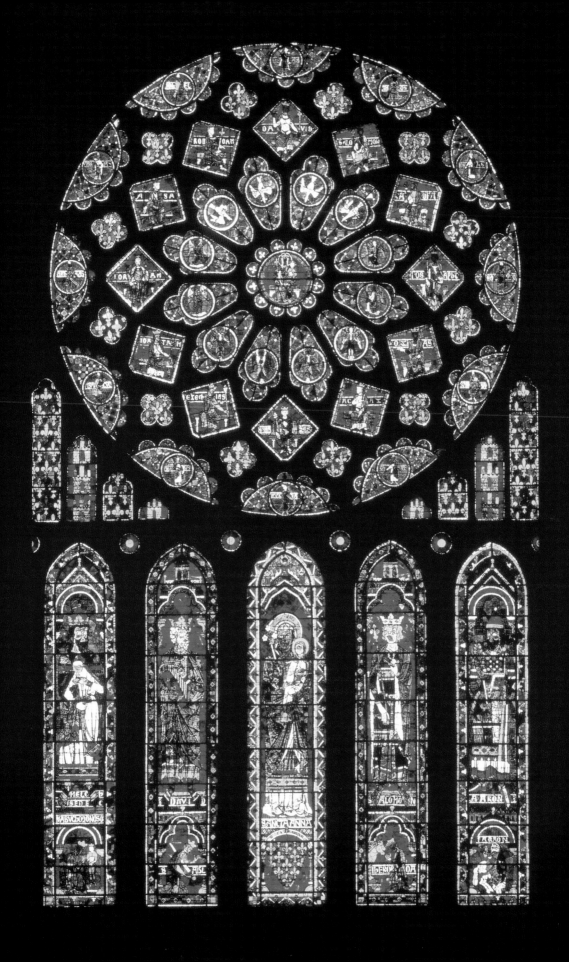

THE RENAISSANCE

A great flowering of Christian art took place during the Renaissance (1461-1600). It was like the bursting of a great dam of creativity rushing through Italy as artists were freed to portray new images. Wealthy traders and politicians used their patronage to finance Europe's leading artists and in the process some of the world's most enduring art was produced. Raphael (below) together with Leonardo da Vinci and Michelangelo (right) were the three central figures of the High Renaissance.

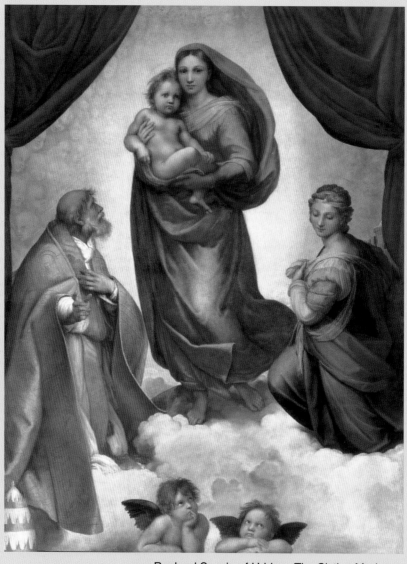

Raphael Sanzio of Urbino, *The Sistine Madonna*
Gemaldgalerie, Dresden, Germany, oil on canvas, 270 x 201 cm

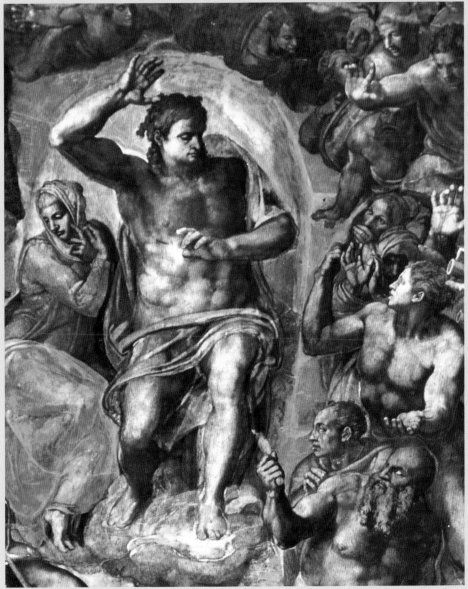

Michelangelo Buonarroti, *The Last Judgement*, Sistine Chapel wall, Vatican Gallery, Rome

Michelangelo Buonarroti was the artistic genius of the Renaissance. His towering figure of Christ in judgement, painted on the altar wall of the Sistine Chapel, Vatican City, broke all the rules of iconographic tradition. A strong and muscular Jesus used new hand gestures to stamp his divine authority on the scene around him.

*I am a poor man
and of little worth
who is labouring in the art
that God has given me in order
to extend my life as
long as possible.*
Michelangelo, January 29, 1542

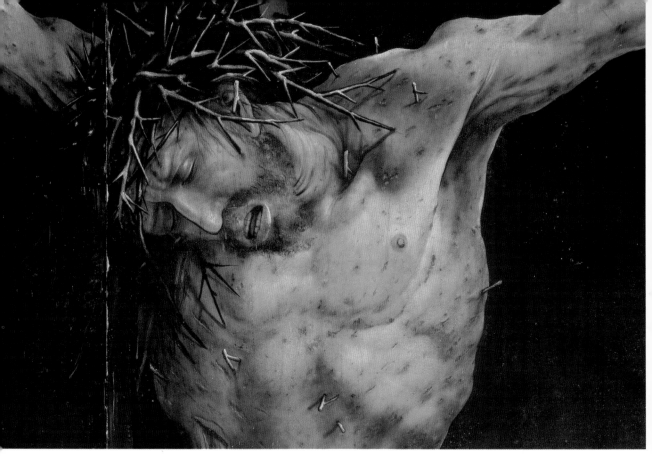

Matthias Grünewald, *The Isenheim Altarpiece*, detail, c. 1516

The Renaissance in the North was dominated by the powerful work of the German artist Grünewald.

"There has been nothing to compare in intensity and variety with the great polyptych by Grünewald now at Colmar in France.

"The Crucifixion is unique in the history of religious painting. It strains the possibilities of the tragic, the static, the mystical and the macabre to a point never reached before or since in Christian art.

"Perhaps it is the one great series of paintings that dwells, almost hysterically, on horror and yet never loses the spirit of reverence for suffering without which Christian imagery would be repellent;

- that tackles the expression of triumphant ecstacy, and yet never falls into sentiment or undue sweetness,

- that attempts the gruesome without slipping into bathos.

"No other artist has approached so nearly to excess on a religious theme without falling into the traps that often await the use of the excessive.

"Here is an artist who could combine the mysticism of the eighth century medieval world, including its sheer ugliness, with the realism of the Renaissance."

- Eric Newton

A WORLD FAITH

Christian art has usually been described from a Western perspective but when missionaries arrived in Asia and Africa they discovered Christian communities which had been in existence for centuries. They also found Christian iconography which had developed a uniquely indigenous style.

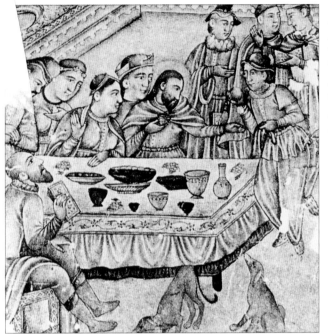

Left:
Indian Christians trace their origins to the Apostle Thomas. An artist's pen drawing from the Mughal period in India depicts a moment from the Last Supper.

Below:
Nestorian Churches were established in China from the seventh century. Two centuries later an unknown Christian painted an image of Palm Sunday on the walls of a Nestorian church in Turfan, China.

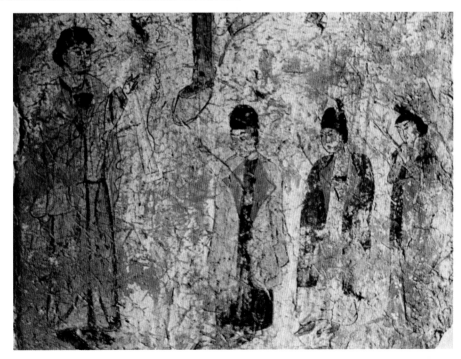

THE REFORMATION

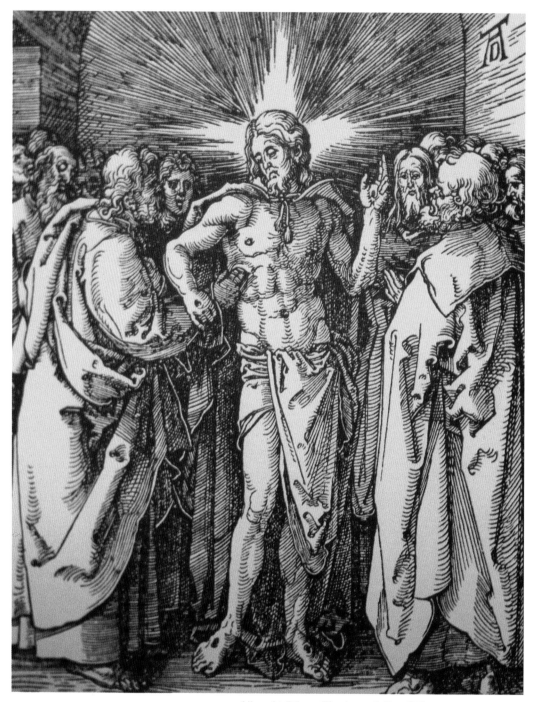

Albrecht Dürer, *The Incredulity of Thomas*, etching, 1511

Albrecht Dürer was a friend of the Protestant Reformation and one of the most influential artists of his time. Thanks to the invention of the printing press, his graphic etchings circulated throughout Europe in great numbers.

BEGINNING THE MODERN ERA

The 17th to 19th centuries brought dramatic change throughout the world. Secular values and individual religion replaced the traditional religious beliefs. Industrialization introduced new growth to old cities. Wars of independence were fought in many lands.

Christian artists sought to find God in this chaos. Baroque artists Bernini, Caravaggio and Rembrandt introduced a Christ who could be identified with the people.

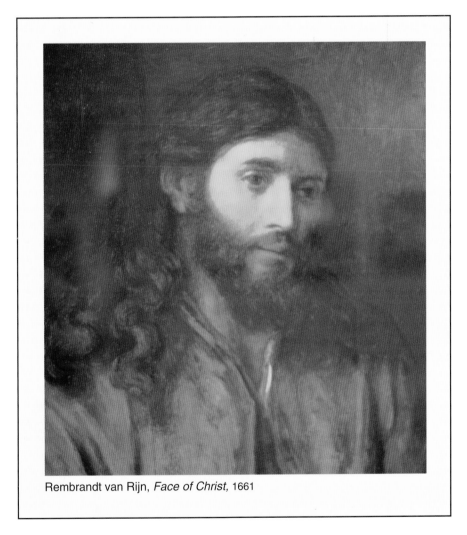

Rembrandt van Rijn, *Face of Christ*, 1661

"Rembrandt broke free from the pressure of the prevailing view and created a personal style of his own. It is a style full of tension for it has to proclaim the most contradictory of all messages - that God the Lord becomes like any other man."
- W.A. Visser 't Hooft

ΑΩ

Through all the changes of the last 2000 years,
Christian artists have challenged the church
with their creativity and their willingness
to attempt new things.
This is the role of the artist as much
as it is the role of the prophet.

Now we enter a new millennium
and a new era.

Do artists of today have the same passion
to present the gospel in contemporary terms?

Let the artists speak for themselves
in the following pages.

CHRIST OUR CONTEMPORARY

The man on a donkey was also a meteor flashing across our firmament. Christ was larger than life. Though he lived among us only briefly, though details are vague and controversial, we have been unable to forget him. Whether he was a messiah, a hero, a martyr, a failure or a fool, we have been unable to ignore him.

Nearly every area of human endeavour, therefore, factored Jesus into its reckoning. Our unique human enterprise of searching for meaning sooner or later leads almost everyone to his door. Even when word spread that God was dead, people kept searching in our rubble to make sure. The result was an immense opus, mostly words written in books: history, metaphysics, Christology and dozens of other disciplines, an achievement without parallel, tomes poetic and scientific, anchored deep in scholarship or flying high in hope.

And yet. When Christ is mentioned, most people admit, it is not the words or the books that come crowding into mind. It is, rather, an image. His picture. It may be unsophisticated as a holy card or grand as an old master. Either way, it is the God we know best. This may say more about us than about him. Considering we don't know what he looked like, only humans could have striven so mightily to create him.

So it was only natural, when time came to celebrate his 2,000th year, that his followers would dust off the picture albums to reminisce. The previous section of this book parades that legendary gallery of masterpieces of which Christianity may be justly proud.

There was, though, something disquieting about the commemorative books that marked the turn of the millennium. The parade stopped short of our time. Was the emphasis on the past due to the fact that there is little contemporary Christian art to boast about? Or was it what so often happens: that we fail to pay homage to new creation until it is safely tucked away in the folds of time?

One indication of the fierce energy that kept Jesus alive from century to century was the constant transformation of his image. Bereft of old photos, equipped only with imagination, artists responded not to the past slipping away but to the future coming to meet them full of challenge and curiosity, a riddle both aesthetic and theological to be solved over and over.

Thus the imagery leapt from catacomb walls to illuminated manuscripts, from Romanesque to Gothic to Renaissance and always onward. Those works survived time because they were of their time, imbued with raw truth and authenticity, reminders as much of who we were as of who Christ was.

If Christian art has faltered in the recent past, it has not done so in a vacuum. Despite humanity's magnificent material progress in the last century or so, the human spirit has experienced a growing entropy. Artists as well as others came riding into the last century on a wave of innovation, from impressionism to expressionism to a plethora of other isms. Some artists looked up and out, others looked inward in fervent self-exploration.

But as the century moved on, conviction faltered. The promise of a brand-new - though highly secular - life never came close to fulfilment, tripped up by world wars, human greed and, finally, psychological and spiritual weariness. This ennui and concurrent slide into minimalism took its toll not only on the visual arts but also on most media. Nowhere was it better articulated than in the work of absurdist playwright Samuel Beckett, condemned, as he said, to go on expressing the inexpressible.

While Beckett never surrendered, many artists and others threw up their hands. Like the rest of the West, the various Christian

denominations lost their nerve. Once the greatest patron ever of the arts, the Roman Catholic Church no longer either supported or inspired artists in a significant way. Whatever it was that had made Jesus the most popular subject of all time, Christianity no longer projected this transcendent quality in such a way as to engage the imagination of artists or even of the faithful. It is no secret that, despite the nominal numbers, the mainline churches are depleted. Our art reflects this.

Such was the unexciting prospect as the third millennium approached. The hype swayed between partying and fears that computer glitches might end life as we knew it. Outside official church circles, Jesus was rarely, if ever, mentioned. I was, at the time, editor of the National Catholic Reporter. To explore this ostracism of the messiah from the culture, we sponsored an art competition. My own curiosity, in guiding the Jesus 2000 project, extended in two directions. Would anyone still care? And if they cared, how would they now see Jesus?

It soon became clear that a wide variety of people cared. This included the media. Word of the competition and, later, the works it produced, was carried around the world in hundreds of newspapers as well as on radio and television.

Artists, too, cared. There were 1,678 entries from 19 countries, in almost every conceivable visual medium. Sr. Wendy Beckett, art expert of BBC fame, made the final adjudication. She lingered over some abstract forms that might be more expressive of our age's misgivings about content and belief.

Then she chose as winner Janet McKenzie's painting "Jesus of the People"(page 31). It was an inspired choice: a dark, indigenous newcomer who belongs to no country and every country, a symbol of the emerging Christianity that, after two millennia of being mostly white and western, is at last at home in what before were foreign mission fields.

It is impossible to describe briefly the staggering variety of images submitted. While a few were traditional, many displayed startling originality of persona or expression. While some were ethereal, many more were immersed in this moment on this earth, from the local diner to war-torn places to death row.

It must be admitted that most of today's best-known artists are not interested in this subject. This says volumes about contempo-

rary art and religion and us. The culture has drifted elsewhere. Yet this competition demonstrated, just below the surface, an immense interest. Enthusiasm for the works was frequently offset by resistance to many of them (as if to say: Don't mess with my Jesus), and often angry resistance to the very attempt to image Christ. This smouldering passion seems to hint that Jesus has become encoded, over the centuries, deep in our genes.

To scratch this aesthetic itch can have exciting, unpredictable and even risky consequences. The historical Messiah by all accounts, turned heads, kicked up dust, and so should his art. Christ was controversial and not average. Art that is new and authentic will also be controversial and not average, and will not be taken for granted.

The range of artworks which follow will have succeeded if they cry out for a second look the way the original Jesus did.

- Michael J. Farrell

JESUS OF THE PEOPLE

Opposite: Janet McKenzie, USA, *Jesus of the People*, oil on canvas, 122 x 76 cm, 1999
First place winner in the National Catholic Reporter Jesus 2000 collection

Jesus of the People simply came through me. I feel as though I am only a vehicle for its existence. Jesus stands holding his robes, one hand near his heart, and looks at us - and to us. He is flanked by three symbols. The yin-yang symbol represents perfect harmony, the halo conveys Jesus' holiness and the feather symbolizes transcendent knowledge. The feather also refers to the Native American and the Great Spirit.

The feminine aspect is served by the fact that although Jesus was designed as a man with a masculine presence, the model was a woman.

≠The essence of the work is simply that Jesus is all of us.

- Janet McKenzie

This is a haunting image of a peasant Jesus - dark, thick-lipped, looking out on us with ineffable dignity, with sadness but with confidence. Over his white robe he draws the darkness of our lack of love, holding it to himself, prepared to transform all sorrow if we will let him.

- Wendy Beckett

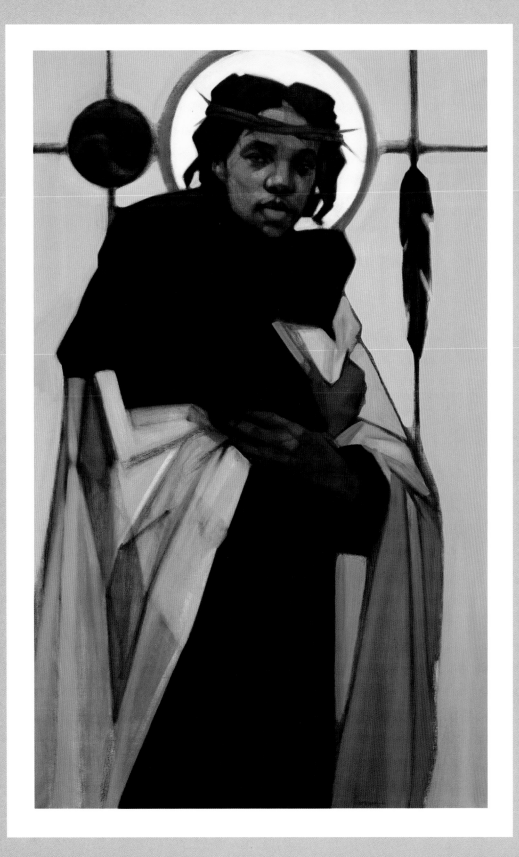

CHRIST THE ENLIGHTENED ONE

When Fr Aloysius Pieris of Sri Lanka, the well-known Jesuit theologian and scholar of Buddhism, first decided to understand Buddhism in depth, he knew there was only one effective way for him to do so.

He prostrated himself at the feet of a saintly Buddhist scholar-monk and pleaded with him to accept him, a Christian, as a disciple, to teach him the Buddha damma (dharma) and the life it entailed. What ensued were years of in-depth dialogue between Fr Aloysius and a number of Buddhist monks of the sangha.

Genuine dialogue of life at such depths always ends up as two-way traffic. The portrait of Jesus here is the work of Bhikku Uttarananda who became a Buddhist monk at the age of twenty and had also come under the influence of the Christian monk Aloysius Pieris.

What does a Buddhist monk see in the figure of Jesus?

Most traditional representations of the Buddha in Buddhist iconography show him either with eyes closed in a posture of meditation or, more often, with eyes lowered and eyelids half-closed in an attitude of renunciation and compassion.

Open staring eyes within this tradition of iconography represent desire to conquer the world for the pleasures it offers. They belong to the haughty, the self-possessed and the uninitiated who look upon the pleasures of this world as the ultimate pleasure.

"There are six things that the Lord hates, seven that are an abomination to him," says the Book of Proverbs, and lists "haughty eyes" as the first of these seven! (Proverbs 6:16-18)

Lowered eyes with eyelids half closed belong, in Buddhist iconography, to those who have conquered the self and its self-centeredness. They represent self-knowledge, compassion, empathy, humility and wisdom.

Anantanand Rambachan, a Hindu, writing about the figure of Jesus, says that what attracted him to the personality of Jesus is the embodiment in him of what he, as a Hindu, considered to be the ideals and values of an authentic spiritual life - the qualities of a Hindu sannyasin (monk). "Here also was a wandering spiritual teacher without home or possessions, fired by the true spirit of renunciation (Vairagya).

"Here also was one who spoke with authority about the limitations and futility of the life which is spent solely in the selfish accumulation of wealth (artha) and transitory sense enjoyment (karma)".

Have Christians, in their anxiety to emphasize doctrinal elements of their faith, forgotten the radical challenges Jesus brings to our spiritual life? "What will it profit them," asked Jesus, "to gain the whole world and forfeit their life?" (Mark 8.36)

Bikku Uttarananda portrays Jesus with lowered eyelids, the enlightened one who has found the true meaning of life and is united in compassion with the suffering of all beings; the rays of the light of life burst through his forehead; the colours are those of the saffron robes of the Buddhist monk and the fire of self-giving.
 - S. Wesley Ariarajah

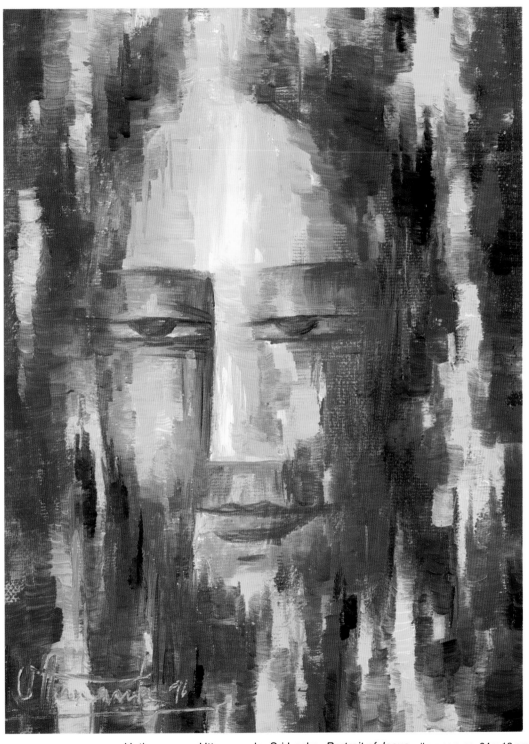

Hatigammana Uttarananda, Sri Lanka, *Portrait of Jesus*, oil on canvas, 24 x 18 cm
© missio Aachen, Art Calendar 2000

MARY THE CHOSEN ONE

Mary's great pain and suffering in her life could break neither
her spirit nor her faith in God. She refused to be victimized.
As an older woman Mary stayed with the disciples and followers of Jesus,
comforting them and holding their shattered dreams
after her son's death. Asian women call her "mother of the church",
the church "not based on hierarchic domination but on
just relationships." (Consultation on Asian Women's Theology, 1987)
They depict old Mary as a wise, strong woman
who gave birth to a new humanity and a new community
through her suffering and undefeated hope.

If Jesus, a Jewish man, became a symbol of new humanity for Asian women, transcending historical, geographical and gender boundaries, so Mary, a Jewish woman, also became another symbol of new humanity for Asian women through her words and deeds. Jesus and Mary, therefore, are two models of the fully liberated human being from whom Asian Christian women find their source of empowerment and inspiration.

Yet many Asian women feel closer to Mary as a model for full humanity than to Jesus, for the obvious reason that Mary is a woman. In Asian churches where the maleness of Jesus has been used against women in order to legitimize the sexist ideology of women's inferiority, women have found comfort and self-worth through the presence of Mary, an invaluable woman for human salvation…

Mary's giving birth to both the Messiah and to a new humanity starts with her saying yes to God's plan for salvation for a broken humanity.

This affirmation of God's plan through her motherhood of Jesus and the new humanity is not mere obedience and submission to a male God but a conscious choice on her part.

Mary's choice is based on her historical consciousness "as a young Jewish girl thoroughly steeped in the traditions of Israel and the historical struggle of her people." (Asian Women's Consultation 1985)

With fear and trembling she takes the risk of participating in God's plan out of her vision of redeemed humanity.

Mary takes this risk not as a heroic superwoman but as an ordinary woman who is receptive to God's calling, which draws her from her own private safety. She is fully aware of the consequences of her choice: social ostracism or even the possibility of being stoned to death according to Jewish custom. But Mary still chooses to give birth to the Messiah and thereby makes possible the liberation of her people.

- Chung Hyun Kyung

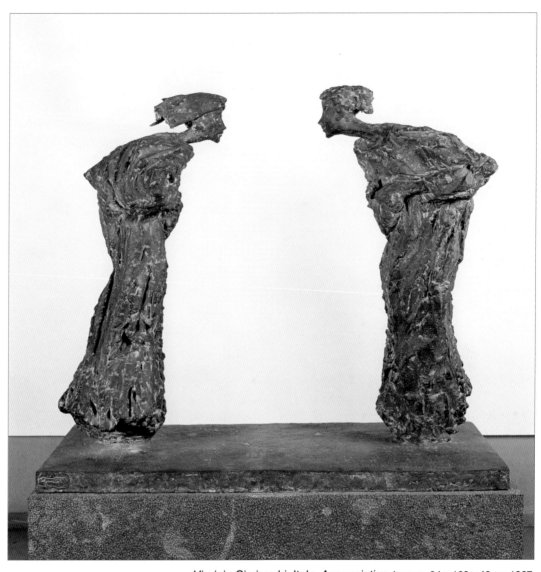

Virginio Ciminaghi, Italy, *Annunciation*, bronze, 94 x 162 x 46 cm,1967

What have you done to me? What have you made of me?
I cannot find myself in the woman you want me to be...
Haloed, alone...marble and stone:
Safe, Gentle, Holy Mary.
(Anon.)

Woelfel, Nigeria, *Annunciation*

36

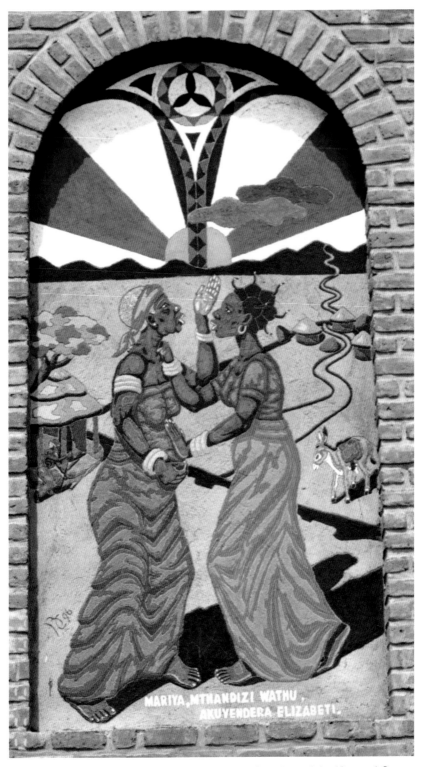

Tambala Mponyani Nsato, Fr Claude Boucher Chisale and the Kungoni Group,
Malawi, *Mary and Elizabeth*, fresco in Mua Mission, 1996

INCARNATION

This painting represents the love of God for our African American people in a voyage of time and space. It shows the history of these people from their beginnings in Africa.

On the lower left side is a Zulu warrior with shield, looking up into the sky; below him stands a princess also looking up; to her left are two slaves, one standing and the other sitting on the ground.

This grouping of figures is the representation of millions of Africans who were brought in shackles from the motherland. They are watching their beloved land disappear over the horizon - a homeland they will never see again.

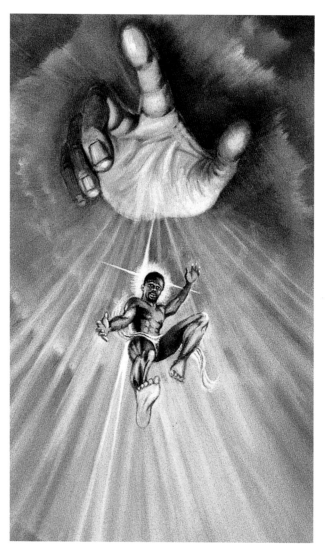

Fernando Arizti, Mexico / USA, *Incarnation* (detail)

In the lower center of the painting are plantations of the deep south where slaves laboured in the fields for many years in the most dehumanizing conditions. These figures look steadfastly up into the sky.

On the lower right side of the painting the figures represent their African descendants. Though their lives have changed significantly since the civil rights movement, still today they are victims of prejudice in most levels of society.

Their pain-filled existence has not been overlooked by the loving and compassionate God.

On the center right side are the souls of the deceased ascending to God as the Son descends from God's hand. "Emmanuel" - God among us.

This is just one facet of a diamond that has many sides. My painting endeavours to emphasize the facet of God made man - the great gift of incarnation for all people of the world in time and in space.

- Fernando Arizti

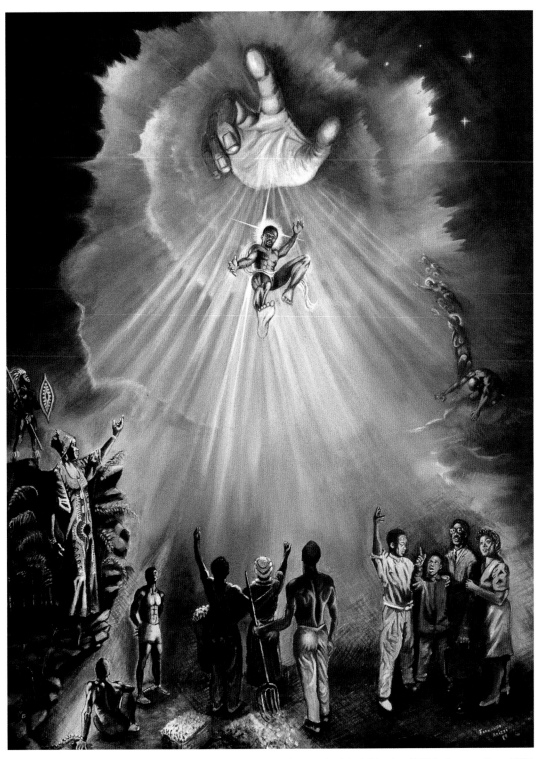

Fernando Arizti, Mexico / USA, *Incarnation,* 1989

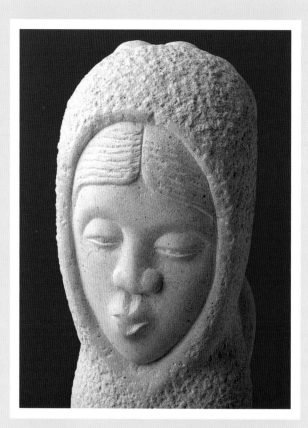

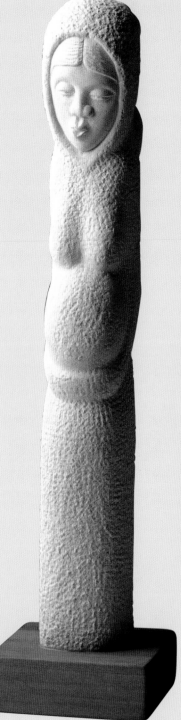

Iosefa Leo Tupuanai, Samoa / New Zealand, *Mele (Mary)*
sculpture, Mt Somers limestone, 57 cm. high, 2000

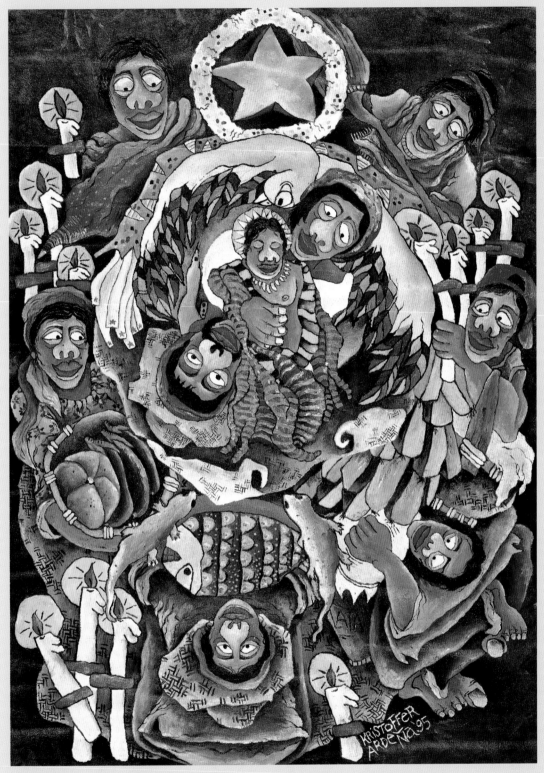

Kristoffer Ardena, Philippines, *The Meaning of Christmas*, oil on canvas, 62 x 46 cm, 1995
© missio Aachen, Prize painting 1995, Art Calendar 1997.

THE BIRTH OF JESUS

Joseph also went from the town of Nazareth in Galilee
to Judea, to the city of David called Bethlehem,
because he was descended from the house and family of David.
He went to be registered with Mary,
to whom he was engaged and who was expecting a child.
While they were there, the time came for her to deliver a child.
And she gave birth to her firstborn son
and wrapped him in bands of cloth, and laid him in a manger,
because there was no place for them in the inn.
(Luke 2.4-7)

The birth of a child usually comes with happiness and joy. But to many teenagers in most of the big cities in Thailand - like Bangkok in the central region, Chiang Mai in the north, Udorntani in the Northeast, Had Yai in the south and other centers, sexual relationship is conducted under a temporary pleasure motivation. In many circumstances, the resulting pregnancy is something unexpected and unplanned.

The birth of these babies is considered a shameful act of disgrace. It is therefore common to see reports of babies discarded soon after they are born into the world because they are unwanted by their young and unprepared mothers.

The birth of the baby Jesus is a planned act of love that is shown and manifested by God the Father.

Chapter 9 in the book of Isaiah is full of well wishes and utmost love from God to all mankind. It is clearly announced: "For unto us a child is born, unto us a Son is given". This child is given to us as a precious and wanted gift for all. It is love demonstrated in the form of an innocent child in the midst of darkness and fear.

This child is given to be the symbol of real happiness and hope. The words "Wonderful Counsellor, Almighty God, Everlasting Father and Prince of Peace" demonstrate the perfect quality of God in Jesus Christ who has come into this world as Lord and Saviour.

Let us open our hearts to invite this precious child, Jesus Christ, to be born into our lives today.

- Pradit Takerngrangsarit

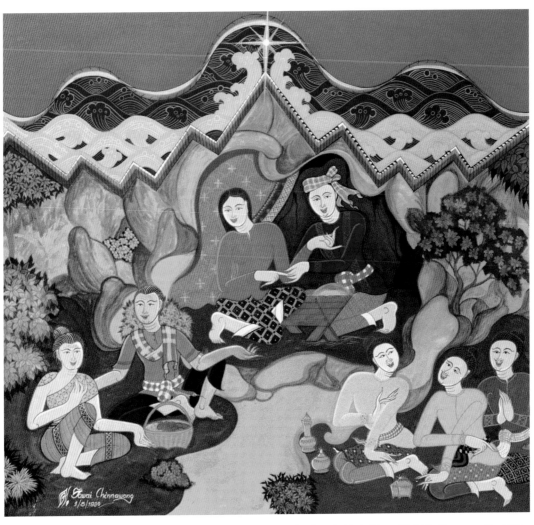

Sawaii Chinnawong, Thailand, *Unto Us a Child is Born*, acrylic, 1990

WISE MEN FOM THE EAST

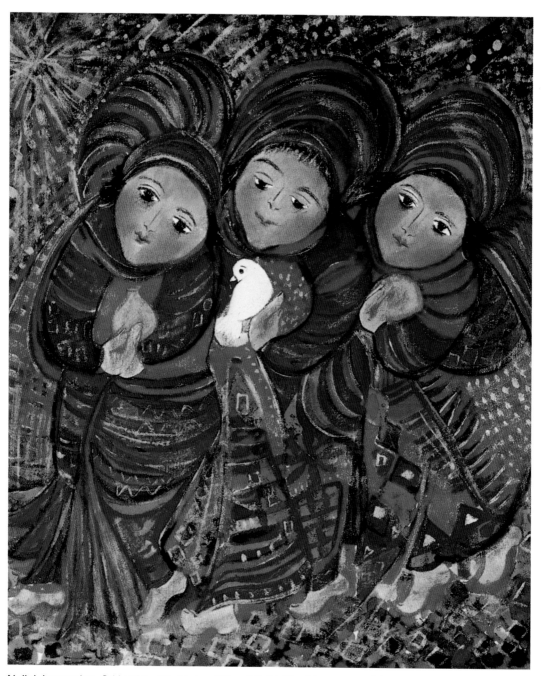

Nalini Jayasuriya, Sri Lanka, *Magi bring Gifts of Gold, Frankincense and the Dove of Peace*
oil pastel on cloth

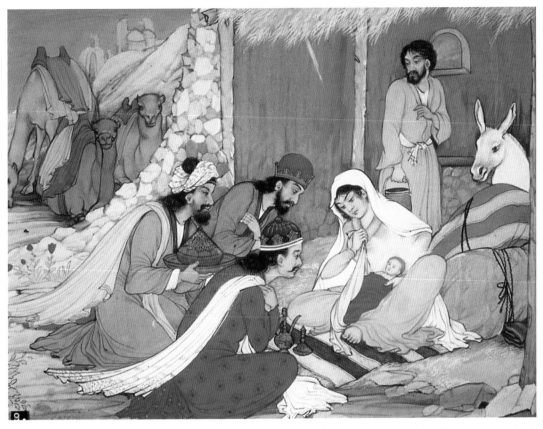

Agha Behzad, Iran, *Wise Men from the East*,
Persian miniature, gouache on prepared glossy surface, 8.5 x 11.5 cm, 1958

Agha Behzad was one of Iran's well-known painters but he lost his way. He violated the laws of his Moslem religion by drinking alcohol and smoking opium. Even his best friends deserted him so he lost both his friends and his religion.

Without hope, he fell into a constant state of drunkenness until a neighbour took him to a Christian gathering. He was attracted by the hymns and decided to find out about Christianity. Behzad struggled through feelings of being worthless and lonely and was eventually rehabilitated from his drug and alcohol addictions.

Given the chance of starting a new life, he was encouraged to begin painting again. This time he was using his art for someone other than himself. He used his talent to paint Christian themes which were used in the church in Iran.

His art portrays Christianity through the eyes of a new convert.

When they saw that the star had stopped, they were overwhelmed with joy.
On entering the house, they saw the child with Mary his mother;
and they knelt down and paid him homage.
(Matthew 2.10,11)

We have been formed by the prevailing consumer society that always wants to put a price on things. We want to be told whether something has a practical use or not and, depending on the answer, we either like or disdain whatever or whoever was in question. Most of us have become victims of utilitarianism and are unquestioning adherents of consumerism.

What commercial value can we attach to a beautiful flower? What about a breathtaking view such as that of Table Mountain with its wisps of mist and cloud forming the proverbial tablecloth. What value can we ever attach to them except that they are beautiful and that we would be impoverished without them. Beauty is self-authenticating and self-justifying.

When the tribal Sans painted their exquisite rock paintings, they did so because they believed that these gave them power in the hunt. But the power they received from these paintings was the power of the knowledge that to be human is to be creative as well. Art, poetry, music, literature, all testify to the fact that we are more than just creatures of our environment - creatures of flesh and the blood we have inside us.

This can be a subversive claim in the face of injustice and oppression and all that would turn human beings into counters to be manipulated, to be pushed and shoved here and there, as if they had not been created in the image of God.

The art of South African townships shows that we are made for other things than to be denizens of the fetid squalor of the ghetto. It is art which shows that, despite everything to the contrary, we do not live by bread alone.

This art is in large measure a protest against race-possessed bureaucrats who like to classify people into neat little packages, but who are nonetheless smart enough to ban cultural events because they know that culture can undermine racist exploitative ideology. Through art, and through creativity, blacks transcend the claustrophobia of their physical environment. They could as easily not engage in artistic activity as not breathe. Blacks are human and one day they too will be freed from all that seeks to make them less.

- Desmond Tutu

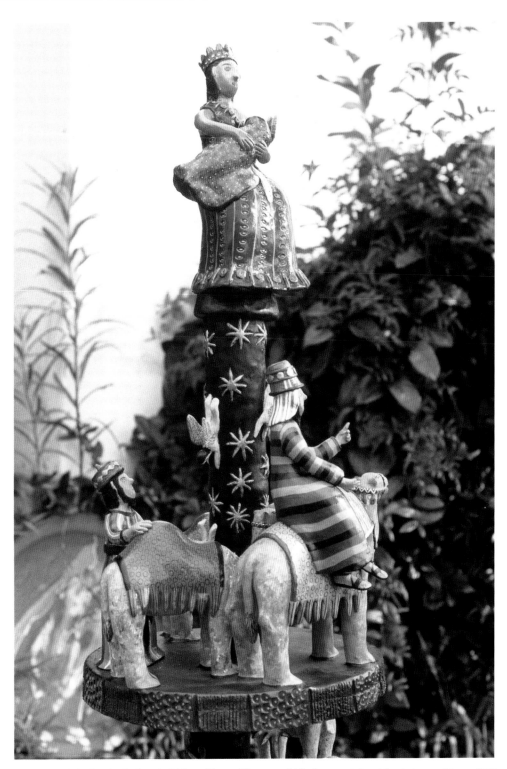

Bonny Ntshalintshali, South Africa, *Three Kings and Madonna*, Painted fired clay, c. 45 cm, 1992

THE MADONNA

"The Madonna in Blue" is a favourite work of Yasuo Ueno, one of Japan's foremost artists.

The colours and composition are well balanced and it is pleasant to look at, which I believe is one of the most important points in any artistic work.

His work is in flat delineation, which could be said to be Oriental. He uses only traditional Japanese paints which are sold as powders of minerals: blue powder of indigo copper ore, green of peacock stone and white of smashed shells.

"I am fascinated," Ueno says, " by the beauty of Japanese paints, which I believe to be the most beautiful in the world. To express the glory of God and the space of infinity I use gold leaf as background colouring, mixing gelatine glue with mineral powder for the silk canvas." Throughout this process the artist adopts the primitive technique of using his fingers only.

The artist's philosophy of life can be understood by studying the faces of Mary and Jesus. The infant Jesus is held by a mother whose build is sturdy and whose strong feet are firmly planted.

Mother and child have identical faces, reflecting the fact that both are the visible face of the one God.

Mary's blue gown is studded with stars, reminding me of the universe where God reigns. On close inspection the stars are small crosses, portents of the future path which the Christ-child will follow in his adult life. - *Yuko Matsuoka*

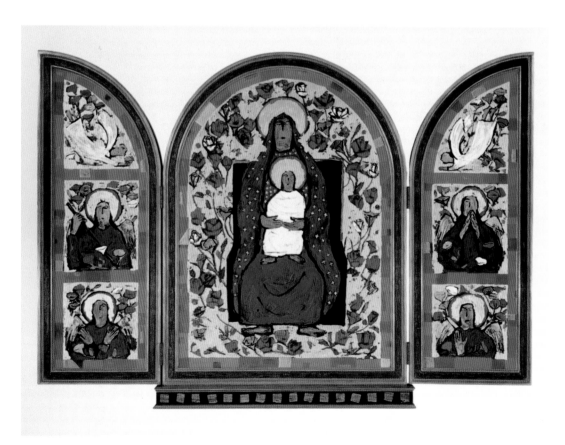

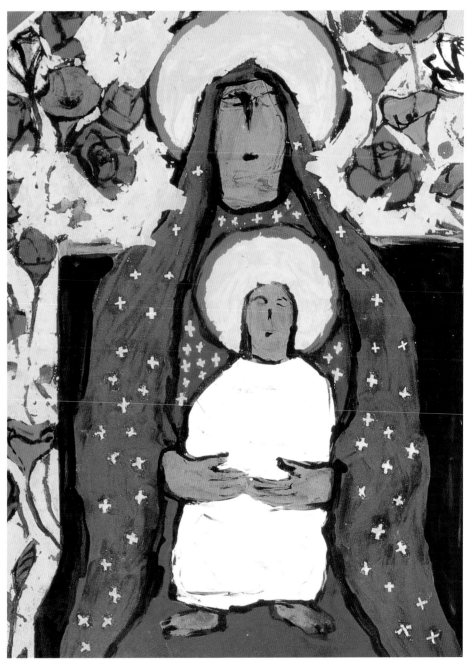

Left: Yasuo Ueno, Japan, *Mother and Child*, Japanese paints, gold leaf on silk canvas, 130.3 x 194 cm, 1997. Above: Detail of central panel

I wish to share the joy I feel when painting with people of the world,
testifying how great it is to be allowed to exist by God,
who has given me my Japanese identity.
- *Yasuo Ueno*

Two such different works of art from Poland and Germany. The icon from Poland is a classic, timeless icon reflecting for us the tragedy that is taking place in neighbouring Ukraine. *The Mother of God of Chernobyl* speaks of the tragedy of nuclear death on which there is no time limit: children with deformed limbs; land that is dead; grief which is unending. The anarchic atom knows no frontiers. Tears flow like rivers with many tributaries.

The Stalingrad Madonna depicts for us Mother Russia with child, proclaiming light, life and love in the midst of darkness, death and hatred. A German military surgeon created her on the back of an army map, deep in a bunker, as the fiercest battle of the Second World War raged above in Stalingrad. It was Christmas 1942. Kurt Reuber, was an artist, a priest and a doctor. A year after painting the Madonna, he died in a Russian prison camp. The paper icon of the Russian mother protecting her child, survived. She symbolizes the untold suffering of millions of Russian women.

Today, she lives on as a spiritual link between the once devastated cities of Stalingrad, (today's Volgograd) Berlin and Coventry. She has pride of place in three homes: West Berlin's central church, a Russian archbishop's home and Coventry Cathedral's new millennium chapel.

Here we have two paintings representing everything that a world of greed and war has rejected. Between them they show the divine and the human face of the eternal feminine in human nature. Their grief, like that of Mary, watching her son cruelly killed, is the grief of the life-bringer and love-maker in every place, at every time, but also beyond time and space.

These two images represent the counter-culture of God's peaceable kingdom. They say no to technology in the service of mammon and mars. Their tears water the garden of life.

We welcome the new freedom which is coming to today's women. But is their emancipation confined to having women in battledress? Or is it about mothers teaching men to be human?

- Paul Oestreicher

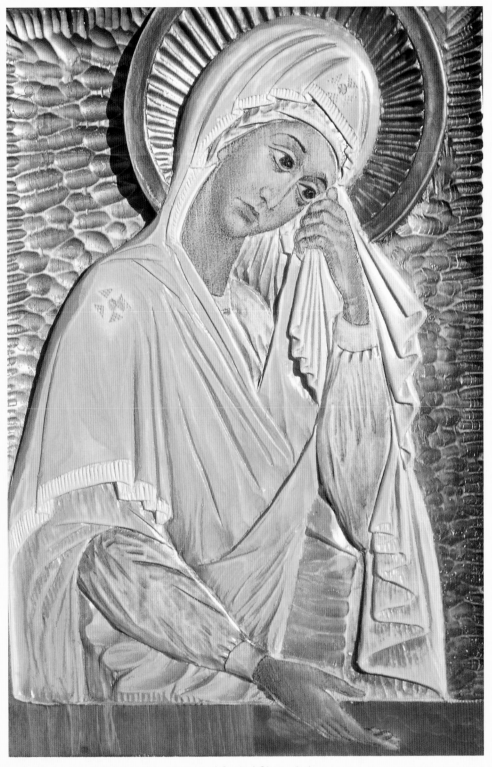

John Solowianiuk, Poland / USA, *Mother of God of Chernobyl*, wood icon, dyes and gilding 56 x 35.5 cm

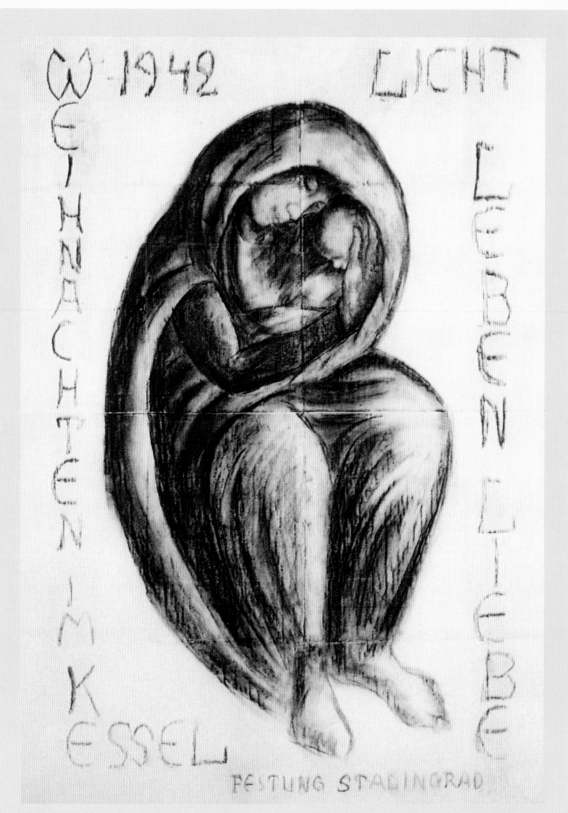

WEIHNACHTEN IM KESSEL · 1942 · LICHT LEBEN LIEBE

FESTUNG STALINGRAD

Kurt Reuber, Germany, *The Stalingrad Madonna*, sketch on paper, Christmas 1942

52

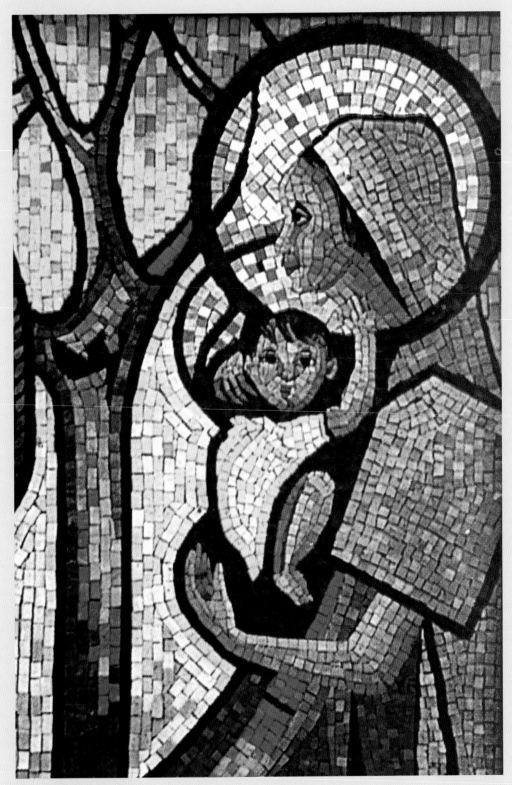

Elizabeth Chan, Philippines, *Mother and Child*, Mosaic

THE MASSACRE OF THE INNOCENTS

It was not an especially pretty world, the world into which Jesus was born. The Palestine of Jesus' day was a world of grinding poverty for the masses, hard labour for a daily pittance, wealthy tax collectors who made their fortunes by extorting money from the impoverished, and brutal military occupiers whose preferred method of crowd control was crucifixion for all who dared to rise up and resist the occupation.

Nor was the town of Jesus' birth an especially peaceful place, hardly the idyllic Bethlehem of our beloved Christmas carol, lying still under the 'silent stars' in 'deep and dreamless sleep'. The Bethlehem into which Jesus was born was one which was soon to know the terrifying clank of military steel, the blood-curdling shrieks of terrified children ruthlessly slashed to death by Roman soldiers 'just doing their job' and the heart-rending cries of anguished mothers inconsolable over the brutal massacre of their innocent infants.

Two thousand years later the picture looks strangely similar. The Palestine of Christmas 2000 is a world of massive unemployment and growing poverty. And the Bethlehem of Christmas 2000, with its sister cities Beit Jala and Beit Sahour, knows only too well the terrifying sounds and scenes of war: the menacing drone of helicopter gun ships, operated by soldiers 'just doing their duty' and raining down death and destruction from the skies; the rapid-fire report of machine guns aiming live ammunition at live human beings in deadly confrontations on the ground; the heavy and horrifying boom of tanks which send shells smashing through the stone walls of ordinary houses, fill children's beds with glass shards, and turn defenceless civilians into refugees without a home; the screaming of Palestinian children, too frightened to go to bed; and the voiced and unvoiced anguish of Palestinian parents, incapable of protecting their little ones from the ongoing terror and the ever-growing destruction all around them.

This is the world and this is the hometown of Jesus Emmanuel - God with us. When God comes to be with God's people, it is not to an idyllic, fairy-tale world of beauty and peace and 'dreamless sleep'. There would, in fact, be no need for 'God with us' in that never-never world. The world that Jesus Emmanuel comes to is the real world that all of us know somewhere, somehow, at some time: the world of poverty and extortion, callous cruelty, unrelenting terror and inconsolable grief. It is this world, and none other, into which God comes to be with us in the person of Jesus, the defenceless child and the crucified Messiah.

The God who comes to be with us in Jesus, born in Bethlehem, is a God who walks our streets, experiences our daily struggles, shares our pain, weeps our tears, suffers our humiliations and dies the most agonizing of human deaths at the hands of his enemies. This is our God, the one who comforts those who mourn, claims peacemakers as children of God and grants inheritance in the kingdom of heaven to those who hunger and thirst for justice. And this is the good news of the kingdom.

Thanks be to God.

- Dorothy Jean Weaver

Zaki Baboun, Palestine, *The Massacre of the Innocents*, oil, 10 x 12 cm, 2001

When Herod saw that he had been tricked by the wise men,
he was infuriated, and he sent and killed all the
children in and around Bethlehem
who were two years old or under.
(Matthew 2.16)

Christians in Bethlehem sent the message opposite
to churches around the world at Christmas 2000.
The following month Zaki Baboun, a young Palestinian Christian,
was asked to paint a biblical work for this book.
His family home had just been hit by a missile and there
were wounded children in the streets of Bethlehem.
The art work he painted (above) comes from these experiences.

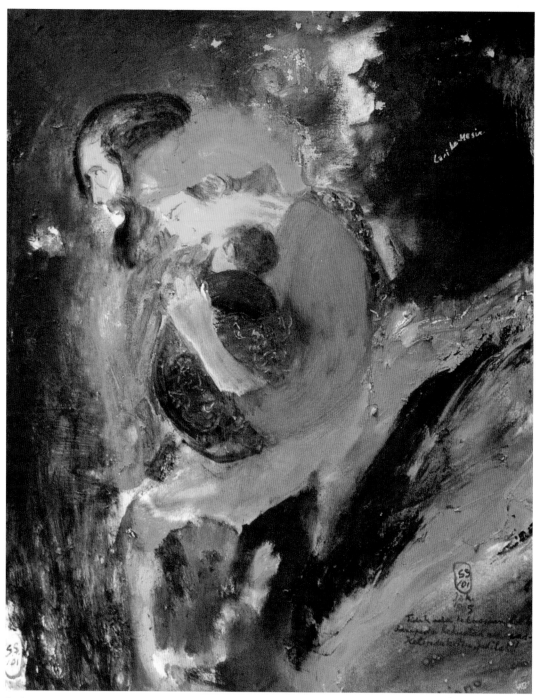

S. Sudjojono, Indonesia, *The Flight to Egypt*, oil, 1985

Andrzej Pronaszko, Poland, *Flight into Egypt*, oil on canvas, 56 x 48 cm

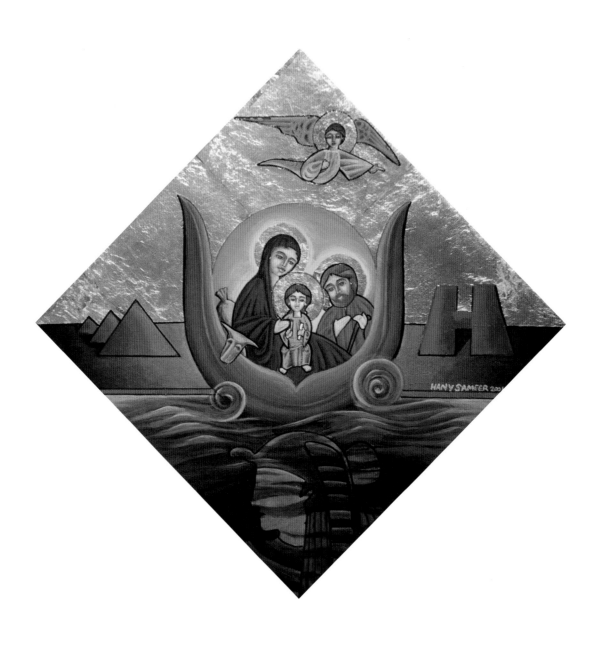

Hany Sameer, Egypt, *Holy Family on the River Nile*, 39 x 39 cm, Coptic icon, 2001

Egino G. Weinert, Germany, *Baptism of Jesus*, 1967-8, 21 x 27 cm

Jesus came from Nazareth of Galilee and was baptized by John
in the Jordan. And just as he was coming up out of the water,
he saw the heavens torn apart and the Spirit descending
like a dove on him. And a voice came from heaven,
"You are my Son, the Beloved; with you I am well pleased."
(Mark 1.9-11)

CHRIST IN THE DESERT

The painting of *Christ in the Desert* confronts us with a majestic figure which dominates the whole desert and its horizon. The stillness of the landscape is absorbed into the motionless attitude of the body. The size of the eyes is striking and they appear to look toward different worlds in bewildered amazement and questioning. At the same time they somehow evoke the majestic look of the Pantocrator Christ in Byzantine and early Romanesque paintings and sculptures. The enigmatic gesture of the hands adds to the impression of mystery that hovers over the whole painting. Christ is dressed in a seamless garment whose soft white colour contrasts with the golden light of the desert sand. The light suggests the pure splendour of Easter morning, which leaves no place for the devil and the anecdotal temptation scenes.

In this painting, van de Woestyne is revealing his own personal experience, that human existence at its deepest level cannot avoid facing solitude. He invites the spectator to identify with him.

Gustave van de Woestyne (1881-1947) was only eighteen when he joined the first group of artists who, in the last years of the nineteenth century, established themselves in Sint-Martens-Latem, a small Flemish village not far from Ghent. During the ten years that he stayed there he was profoundly influenced by the collegial discussions on cultural and spiritual matters that initially bound these artists together.

At a decisive moment in 1905, he made the option of entering the novitiate of a Belgian Benedictine abbey but had to give up his experiment after three months. The rest of his life, however, continued to be marked by a deep spiritual and religious search that is reflected in many of his paintings.

In 1939 he painted the impressive *Christ in the Desert*. One wonders whether he may have tried to link his own Flemish surname "van de Woestyne" meaning "of the desert" with the Gospel scene of Christ dwelling in the desert during forty days. The artist, who suffered from inner solitude during the major part of his life, may also have been influenced by painters such as James Ensor who did not hesitate to call one of his Passion paintings *Ensor's Crucifixion*.

Van de Woestyne's work is not a self-portrait in a physical sense but it may well be an endeavour to identify his own psychological and spiritual state of mind with Christ's experience of solitude in the desert.

- Harry Gielen

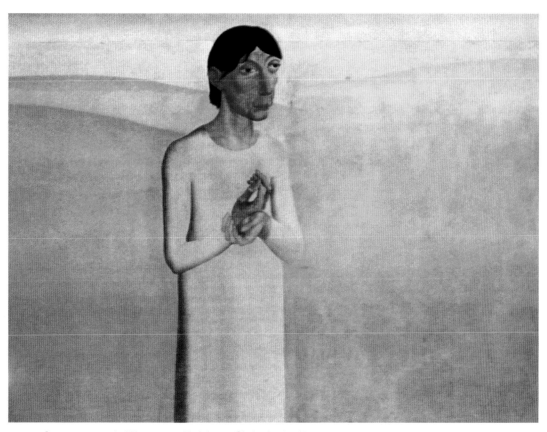

Gustave van de Woestyne, Belgium, *Christ in the Desert*, 1939, tempera on hardboard, 122 x 169 cm

Jesus, full of the Holy Spirit, returned from the Jordan
and was led by the Spirit in the wilderness,
where for forty days he was tempted by the devil.
He ate nothing at all during those days,
and when they were over, he was famished.
(Luke 4.1,2)

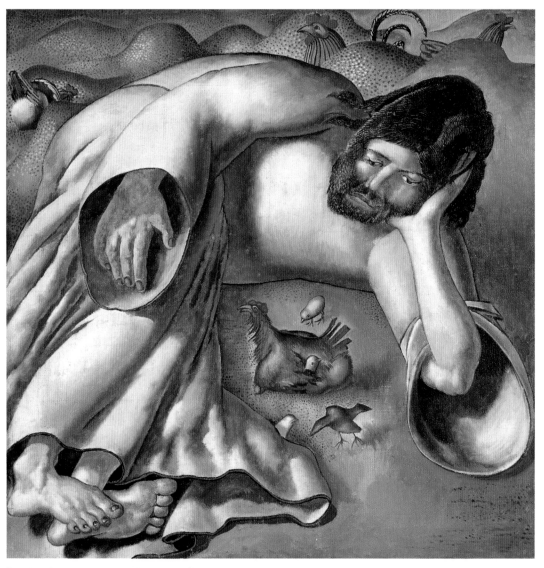

Stanley Spencer, United Kingdom, *Christ in the Wilderness - The hen,* 1955, oil on canvas, 56 x 56 cm

Between the years 1939 to 1955, Stanley Spencer painted a series
of eighteen works on Christ in the wilderness.
They began as a reflection of his own spiritual journey at a time
when he planned to live as a hermit. In his search for simplicity and
purity he took strength from the wilderness experience of Christ.
His last completed work (above) is based on the text below.

(Jesus said:)
"How often have I desired to gather your children together
as a hen gathers her brood under her wings..." (Matt 23.37)

TEMPTATION

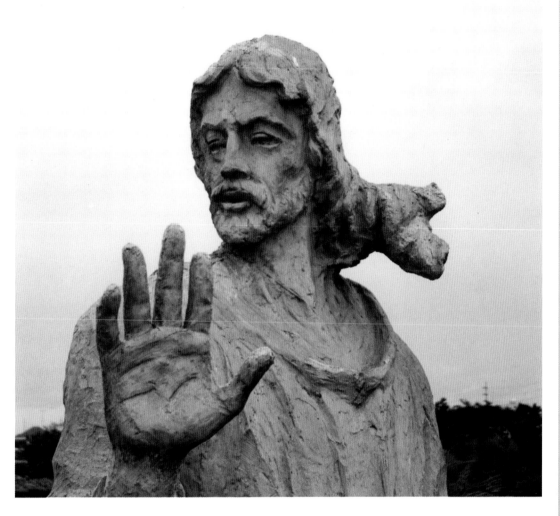

And Jesus said to him, (the devil)
"Worship the Lord your God
and serve only him."
(Matthew 4.10)

Napoleon Abueva, Philippines
The Temptation of Jesus
life-size sculpture, reinforced concrete

Lawrence Sinha, Nepal, *The Life of Jesus*, watercolour, powder colour and 22 carat gold on Nepalese cotton based on the art of ancient Nepalese painted scrolls (Thanka).

LORD'S PRAYER

Nikhil Halder, Bangladesh, *Lord's Prayer*, 1980, acrylic

(Jesus said) Pray then in this way:
Our Father in heaven, hallowed be your name.
Your kingdom come.
Your will be done, on earth as it is in heaven.
Give us this day our daily bread.
And forgive us our debts, as we also have forgiven our debtors.
And do not bring us to the time of trial,
but rescue us from the evil one.
(Matthew 6.9-13)

CHRIST AND THE FISHERMEN

Sometimes the Church emphasizes the divinity of Christ over his humanity. We often do not take seriously the humanity of Christ. And yet it is God's humanity in Christ, God's love and solidarity with people that really matters.

Christ the incarnate Word of God is the ultimate symbol of God's solidarity with the humankind whom God created and loved. Taking the form of a human being, God in Jesus identified with ordinary people. Fishermen are among those with whom Jesus relates as friends and family.

In this painting, Indonesian artist Bagong Kussudiardja seeks to portray something new in society and yet something very common. He has painted Jesus as one of us, wearing sunglasses and talking with the fishermen on the shore of the sea.

Christ who identified himself with us brings hope to this world. God's solidarity with people and all of creation means that God is here with us, dwelling among us. Emmanuel!

- Judo Poerwowidagdo

Technology has become the symbol of progress. Only a few people realize that they are losing something very valuable - their sense of identity, value and purpose - their very life and personhood.

Modern people are busy people. Exceedingly busy! But when they arrive home how often they feel only tired and empty. They do not feel there is any profound and long-lasting meaning or value in what they have done or produced. Why? Because often people only know 'how to do something' without bothering to ask, "Why are we doing this?" or "What is the meaning and value of doing this?"

This very sense of emptiness is precisely the subject of art and religion. Art and religion can fill the gap because their function is to give meaning.

Art extracts and distils meaning from ordinary human experiences. It is so because art treats ordinary human experience as an end in itself, as something which has an intrinsic value in and of itself, not merely a means or technique for achieving some other end. What is ordinary, through art is recreated into something extraordinary, to be enjoyed and experienced anew. The void within the soul is filled with joy and inner peace or, perhaps, with anger or frustration, but certainly not without meaning....

Through art we see the unseeable.

- Eka Darmaputera

Bagong Kussudiardja, Indonesia, *Christ and the Fishermen,* 1998, oil

Art is part of my life. I feel that one needs art
just as one needs food, clothing and shelter.
I live every day receptive to everything surrounding me,
open to the past and things inherited from my ancestors,
open to the present and to the future.
Even though something may be very small,
I try to understand it completely, since human life must be able
to appreciate the vitality of all things.
- Bagong Kussudiardja

Kim Jae Im, Korea, *Jesus Blesses the Children,* 1998, paper collage

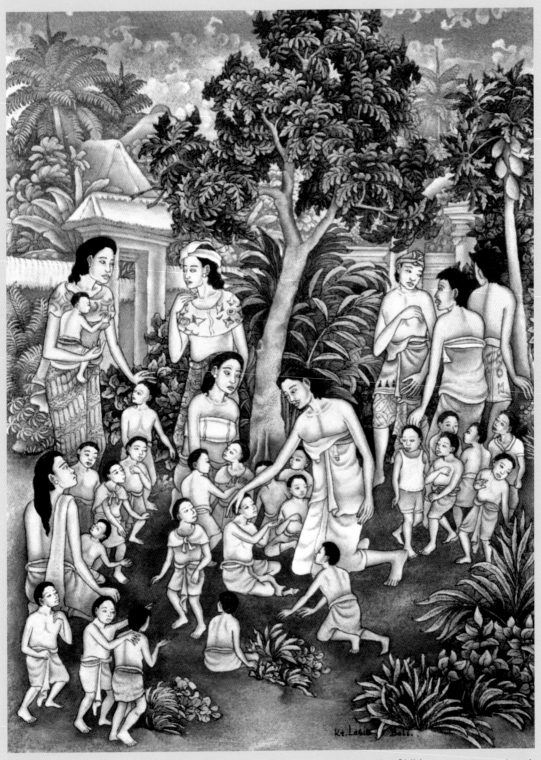

Ketut Lasia, Indonesia, *Jesus Blesses the Children*, 1994, pen and wash

THE WOMAN OF SAMARIA

What brought these two people together? Not religion; religion was a cause of tension between Jesus the Jew and the woman of Samaria. Not gender; gender separated him a male and her a female. It was water that brought them together. The tired and thirsty Jesus needed water and the woman of Samaria came to the well to draw water. Water became the subject of their conversation, the water that would quench Jesus' thirst and the water the woman of Samaria needed for daily life. There is nothing religious about water. Nor was there anything spiritual about it. Jesus simply asked her, "Give me a drink."

But hardly had this simple request left Jesus' mouth when water turned into a religious matter and changed into a spiritual substance. "How is it that you, a Jew," taken aback, the woman of Samaria responded, "ask a drink of me, a woman of Samaria?" The water that had brought them together was about to estrange them again when it was turned into a religious and spiritual matter.

Yet it is not this tense moment but another moment in the conversation that the painting "The Woman of Samaria" captures - a moment of compassion and ecstasy.

The subject of the conversation is still water but it is a different kind of water - water of eternal life. Jesus is no longer a Jew, and a male at that, but someone filled with the water of eternal life and refreshed by it. His eyes are looking at the woman of Samaria in compassion, the eyes shining with water of eternal life. His mouth that has just uttered the words "water of eternal life" is still open slightly, savouring those sacred words. And his hand! It is filled with the power of eternal life ready to impart it to the woman of Samaria.

And the woman of Samaria? She is no longer her contentious self. Her eyes, in quiet ecstasy, are directed to Jesus who manifests eternal life.

Her entire person, though still leaning a little away from Jesus, seems to begin to be inflated with eternal life from Jesus. She has forgotten she is a woman of Samaria, and she is not conscious of being a woman of Samaria keeping a distance from Jesus a man.

Her entire being exudes a fascination for Jesus who is the water of eternal life. It is now her turn to ask him, "Sir, give me this water."

Eternal life is the heart of faith. It is the vision of life. And it is the goal of our spiritual journey on earth.

- *Choan-Seng (C.S.) Song*

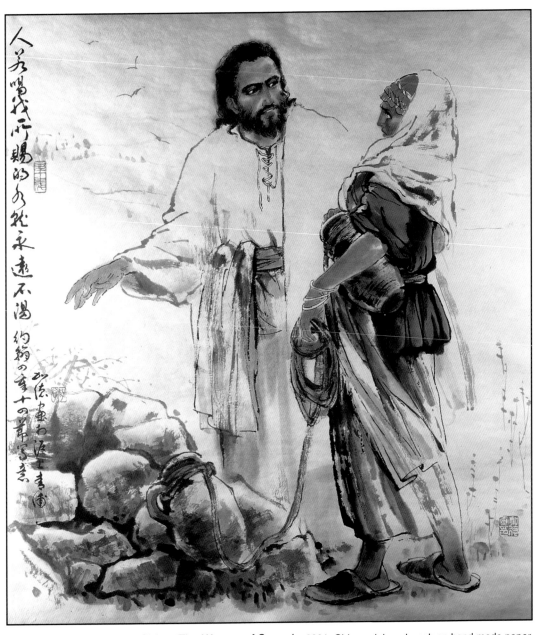

Yu Jiade, China, *The Woman of Samaria*, 2001, Chinese ink and wash on hand-made paper

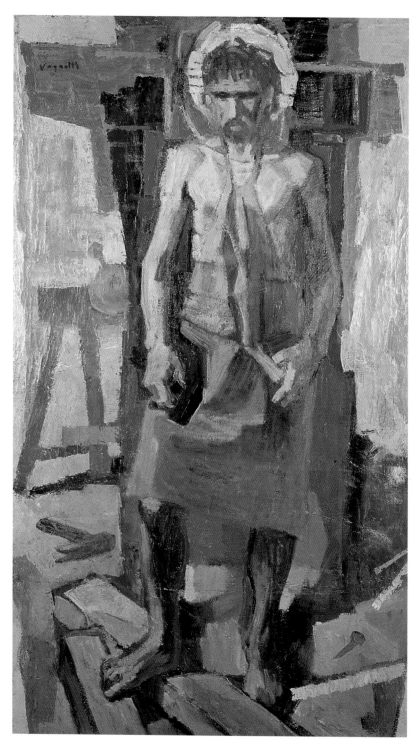

Gianni Vagnetti, Italy, *Jesus, Divine Worker*, oil

JESUS AND THE ADULTEROUS WOMAN

Jesus bent down and wrote with his finger on the ground.
When they kept on questioning him, he straightened up and said to them,
"Let anyone among you who is without sin be the first to throw a stone at her."
(John 8.6b,7)

Lee Myung Ui, Korea, *Persecution*, 1981, watercolour

CHRIST THE PREACHER

*"The Spirit of the Lord is upon me, because he has anointed me
to bring good news to the poor. He has sent me to proclaim
release to the captives and recovery of sight to the blind,
to let the oppressed go free.* (Luke 4.18)

South Indian artist Alphonso, who has been deeply influenced in his creations of Jesus by Rembrandt, envisions Christ basically as a man who arrived on earth to sacrifice his life for the cause of humanity.

Alphonso started drawing for the church as a schoolboy and was encouraged in his art by priests and Christian missionaries. He says of Jesus:

"No other religious master has been so personal, so communicative and so lovable as Christ, ready to lay down his entire life in fulfilling the needs of society. He has been a suffering symbol for painters for centuries."

Alphonso's Jesus is not just all human detail. His gracious head is framed by a halo, the purpose of which is far from decorative. To the artist, Jesus represents a great spiritual force. The power of uniting the human and the divine is the root of the importance of Alphonso's art.

"Jesus always said that he was the Son of God and he also said 'I am the Way... My father in heaven guides me.' I have a feeling," says Alphonso, "that he was convinced that the heavenly father lived in him and he was part of him. That gave him extraordinary power to carry on with his mission and life."

In believing so, Alphonso does not want to take too great a liberty with the image of Christ. His religious feeling inspires him with great respect and veneration. His paintings of Christ have a severe grace, dignity and monumentality. He states:

"I have always thought of Jesus as a person of eastern origin. He was a Jew, an Asian. I have invariably conceived of Jesus as a bronze figure that comes naturally to me, and then I add other colours - deep orange, yellow and even black - to suit my compositions."

In Indian images of the Buddha or Jesus as great teachers, the left hand rests on the chest and the right hand is extended in the preaching posture, with the first two fingers pointing upward and the third finger held against the palm by the thumb. We see this posture in Alphonso's work *Christ Preaching*. In his left hand Christ holds an egg, symbolizing the source of life.

Our way to eternal life lies in following the teachings of Jesus.

- Anjali Sircar

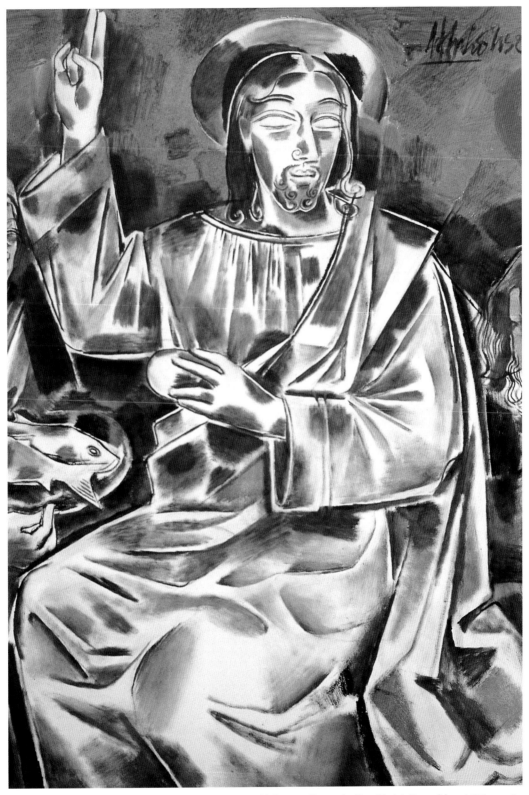

Alphonso Doss, India, *Christ Preaching*, 1998, acrylic

SERMON ON THE MOUNT

Blessed are the pure in heart, for they will see God. (Matthew 5.8)

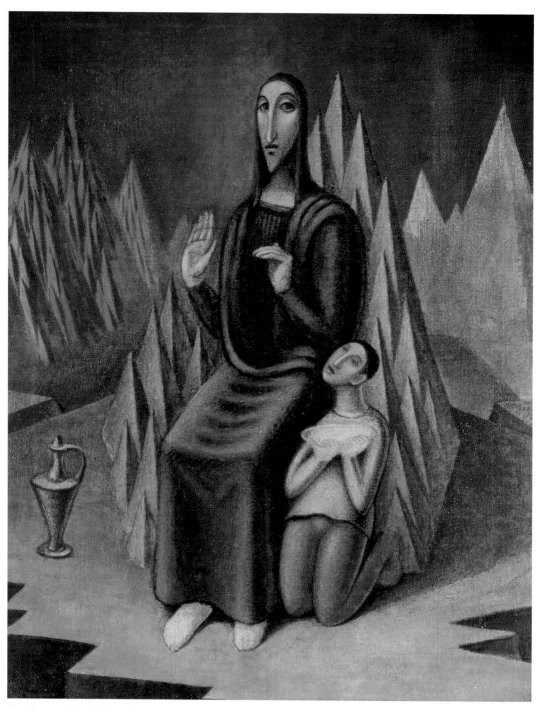

Jan Zrzavy, Czech Republic, *The Sermon on the Mount*, oil and tempera on canvas, 74 x 58 cm

PARABLE OF THE LOST COIN

Rejoice with me, for I have found the coin that I had lost. (Luke 15.9b)

Joseph Scott, Pakistan, *The Lost Coin*, 1991, pastels, 28 x 22 cm

THE GOOD SAMARITAN

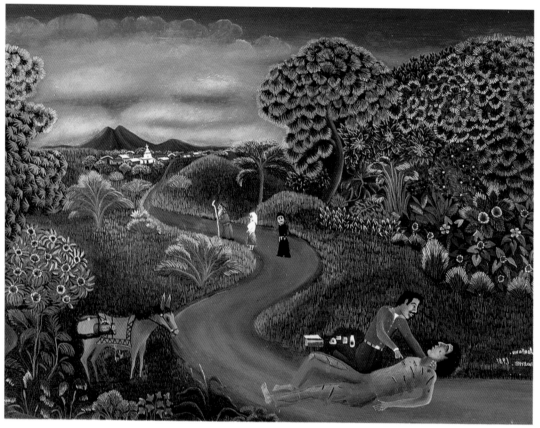

Rudolfo Arellano, Solentiname, Nicaragua, *The Good Samaritan,* 1981-2, oil colour on linen

The parable of the Good Samaritan is one of the best-known stories of Jesus and a favourite with Christian artists. It begins with a spiritual question from a lawyer, "What must I do to be saved?" but quickly moves to a very practical social issue, "who is my neighbour?"

The response of Jesus is to tell a story in which a member of the despised Samaritan community is the hero. In doing this, Jesus affirms those people who are different from ourselves but whose compassion binds them to us in a common humanity.

The two paintings (above and right) illustrate through different village cultures the truth that Jesus wanted to convey to the lawyer who was caught up in legalistic doctrine: the people we think of as inferior to ourselves are also people of God who sometimes can teach us about God's compassion.

Just then a lawyer stood up to test Jesus.
"Teacher," he said, "what must I do to inherit eternal life?"
(Luke 10.25)

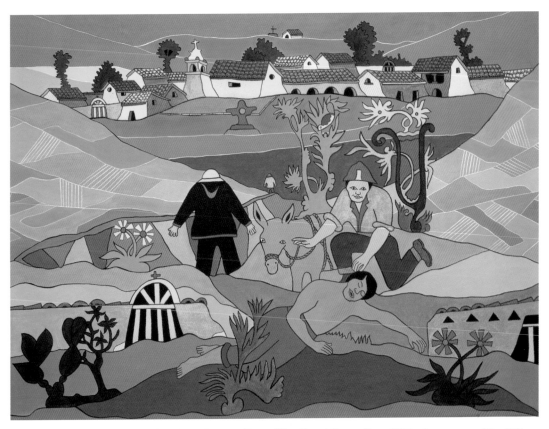

Josué Sanchez Cerron, Peru, *The Good Samaritan*, 1982, oil on canvas, 86 x 126 cm
© missio Aachen, Art Calendar 1984 Peru

The story of the Samaritan showing mercy to the victim of robbers invites us to walk in the shoes of another person.

Can we imagine the indignity of being stripped of all our possessions, without home, without food, without work, denied the right to own land, deprived of political participation, to face discrimination because of our religious belief or because of the colour of our skin.

The answer to the question: "who is my neighbour?" is found when we internalize the sufferings of others so that they become our own. Our sympathy will then take on that deeper dimension of compassion so evident in the life of Jesus.

We need to feel what it means to be the victim in order to be the Good Samaritan.

- Alison O'Grady

CHRIST THE LIGHT

Without love for humans, I can neither believe in anything
nor gush out the energy in my mind. To keep painting pictures
until the time when God will appear over the canvas
will surely be my destiny and the bearing of my cross.
- *Yoko Makoshi*

In the painting of Yoko Makoshi, *Darkness and Wisdom*, we see a man sitting in anxiety under the shadow of darkness. The figure on the left side of the painting is bringing light to the man, lifting it towards his head to dispel the darkness that invades his spirit. Two friends look on, one pointing towards the light.

The artist received this image when she read in the Book of Job: "They make night into day; 'The light,' they say, 'is near to the darkness.'" (Job 17.12)

This promise that Job made is fulfilled through the incarnation of Jesus Christ, as John testifies:

"The light shines in the darkness, and the darkness did not overcome it... The true light, which enlightens everyone, was coming into the world." (John 1.5,9)

The struggle between darkness and light has been the major theme of the life and work of Yoko Makoshi who, in her younger days, was brought up in an atmosphere of idealism. She chose the themes of the romantic poems by John Keats for her graduation thesis at Tokyo Women's University.

But this focus changed one day when she went to a long-established bookstore in downtown Tokyo to search for further material on Keats. When she came across works by William Blake she was immediately impressed by the struggle between light and darkness which he so realistically portrays.

As a result, she sold the books she had collected on Keats and bought works by Blake on which to base her graduation thesis, entitling it "Emancipation of Humanity - a Study of Blake's Faith".

During her adult life Makoshi experienced an ordeal of suffering brought about by the prolonged mental sickness of her husband. This caused her to express through her art the reality of life against the background of suffering and hope.

Yoko Makoshi was selected as winner of the Grand Prix of Yasuda Kansai Museum of Art in 1994 with the citation that her art is an expression of the deep spirituality of human emancipation.

- *Masao Takenaka*

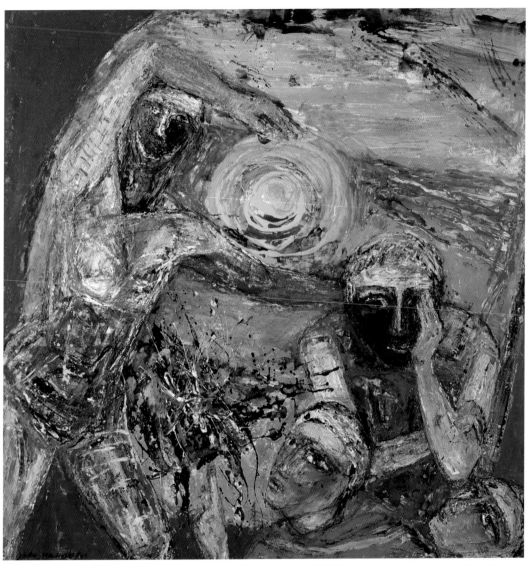

Yoko Makoshi, Japan, *Darkness and Wisdom*, 1999, silk canvas, 162.1 x 162.1 cm

SOWING THE SEED

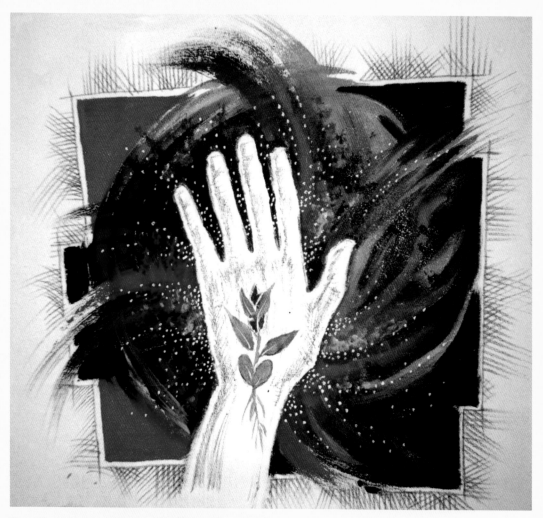

Than Oo, Myanmar, *Sowing the Seed*, 1996, acrylic

Now the parable is this: The seed is the word of God.
(Luke 8.11)

(The Kingdom of God) is like a mustard seed that someone took
and sowed in the garden; it grew and became a tree,
and the birds of the air made nests in its branches.
(Luke 13.19)

CHRIST THE TRUE VINE

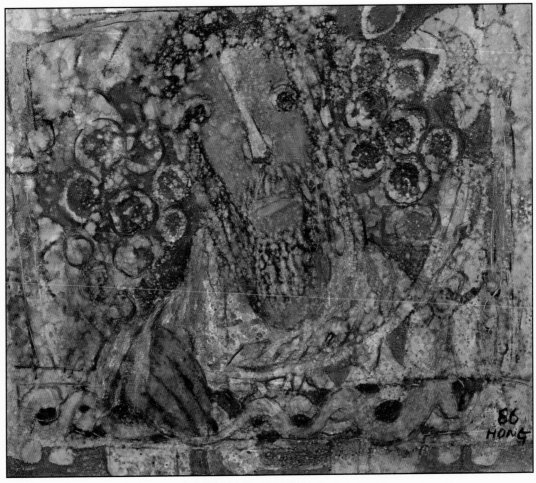

Hong Chong Myung, Korea, *Christ the Vine*, 1972, traditional Korean paint

(Jesus said)
I am the vine, you are the branches.
Those who abide in me and I in them bear much fruit,
because apart from me you can do nothing.
(John 15.5)

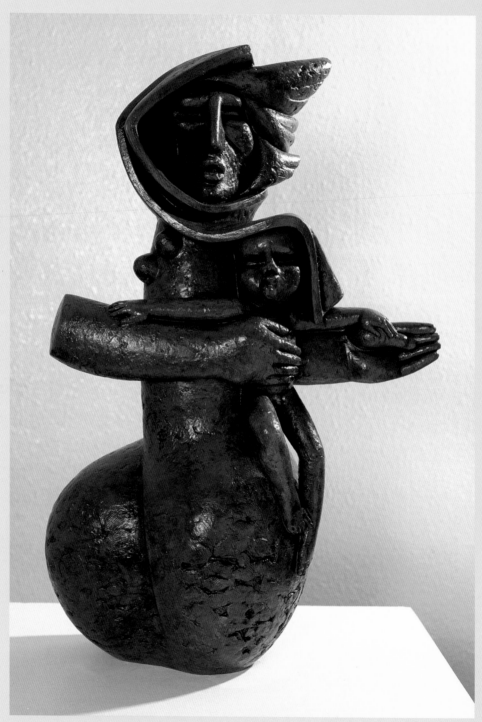

Ng Eng Teng, Singapore, *The Way*, 1987, cement-fondu, 102 x 68 x 40 cm

CHRIST THE GOOD SHEPHERD

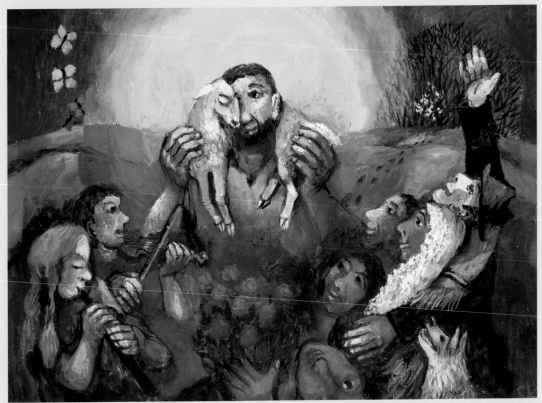

Sieger Köder, Germany, *The Good Shepherd*

(Jesus said)
I am the good shepherd.
The good shepherd lays down his life for the sheep.
...I have other sheep that do not belong to this fold.
I must bring them also, and they will listen to my voice.
So there will be one flock, one shepherd.
(John 10.11,16)

CHRIST THE DOOR

Fan Pu, China, *Christ the Door*, 1999, paper cut, 42 x 34 cm

CHRIST THE ANCHOR

Like many Tongan artists, Filipe Tohi recites a traditional chant as he works.

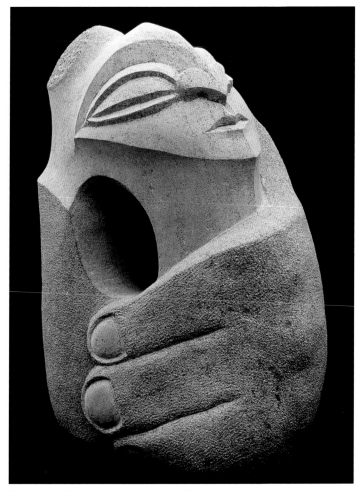

Filipe Tohi, Tonga / New Zealand, *Fakaukau*, 1996, stone carving

God of the heavens
Creator of the land
Creator of the mountains
I stand here and wait
You are the light
Give me a glimpse of
Your presence
So your countenance
My carving will reflect
Token of my appreciation

When the work
is completed,
a new chant begins:

The flower has bloomed
The stone is carved
For all to see
Behold where it stands
The stone waits
Filled with the past
For the children
Of tomorrow
Stand up and proclaim
To all the visitors
The beginning of this
And its accomplishment

Tongan people know the need for God's presence with them as
they go out in their boats to fish the waters of the ocean, sometimes
encountering unexpected storms. The artwork reproduced here
reflects this. The shape is based on the anchor stone through which
the rope is tied. The eye represents the canoe; the hand of God
holds the boat and the people securely as they float
on the life-giving water.

Over the centuries quite a few male artists have used themselves as models for Christ in their works. This identification does not necessarily imply blasphemous self-glorification. Instead, it can bear witness to a mysterious encounter with the Lord in moments of deepest despair. In modern religious art - as sometimes in medieval art too - it also happens that different motifs are fused into one: *Gethsemane*, *Carrying of the Cross* and *Ecce Homo* are given a concentrated interpretation in *Man of Sorrows*.

Female artists are more inclined to move towards images of the Virgin or a feminine interpretation of God (the Mother) even when the motif is Christ. All this applies to the very complex tapestry by Sandra Ikse which is, of course, first identified as crucifixion but also carries traits of the Mater Dolorosa (Our Lady of Sorrows) and the sheltering Madonna of Mercy.

The tragic background of the work is the sudden death by drowning of the artist's son Lucas, aged four. Not knowing whether to follow him in death or not, Sandra Ikse had to spend a long time in hospital, and when she later made a huge tapestry (387 x 337 cm) it was a decisive turning point. She used the Christian iconography to reflect and bear her personal tragedy and named it *I Will Choose Life.*

At the foot of the cross we see the grandmother and grandfather of the dead child in the traditional places of Mary and St John. Between them is the face of Lucas with his intense eyes, ever absent and ever present in his mother's life. We also see the serene silhouette of a traditional mother-and-child as a sign over his face.

Whirling entrail-like fields lead upward to the foetus of a child yet to be born. At the beam of the heart-like cross we see portraits of the child's father, the surviving brother and sister, and Lucas' silhouette as still a member of the family. Then lastly, the mother's face, shown with a crown of thorns made out of the imprints of Lucas' palms just as his warm handprints still linger on her cheeks.

When all languages come to an end, the religious one remains. As the title indicates, this is a truly life-giving piece of art. It is moving and awe-inspiring that traditional Christian iconography can, even today, serve as a redeeming instrument in situations of uttermost despair.

In its fusion with the tormented artist it will reflect the Crucified's presence in the suffering of all humanity at all times and in all ages.

- *Elisabeth Stengård*

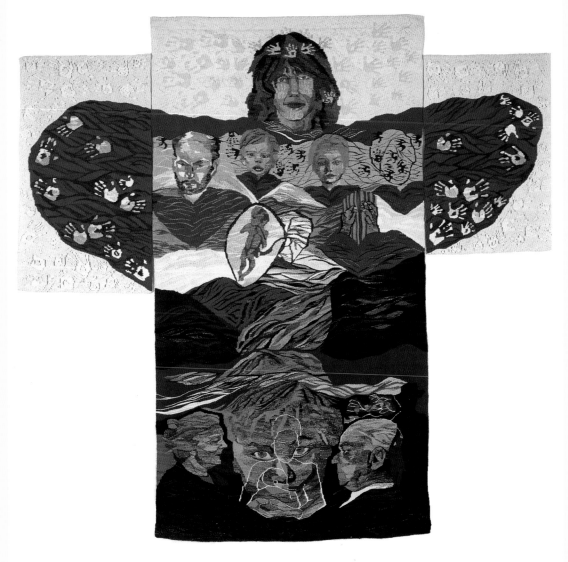

Sandra Ikse, Sweden, *I Will Choose Life*, 1977-79, tapestry, 387 x 337 cm

Jesus said to her, "I am the resurrection and the life.
Those who believe in me, even though they die, will live,
and everyone who lives and believes in me will never die.
Do you believe this?"
(John 11.25-26)

CHRIST THE TREE OF LIFE

The Indian School of Art for Peace is an art ashram in the countryside near Bangalore. Artists from around the country gather to participate in workshops and discussion on how to relate their art to the reality of the communities in which they live.

The two women artists, Sebastiana Dung Dung and Cecilia Billung, who designed and painted the batik art-work *Tree of Life* (opposite) lived and worked in the ashram for some weeks. They belong to the Kharia tribe and their village is in Sundargarh district, on the border between Orissa and Chotanagpur. The ancient tribal festival of Karam is an important event in this region and is a time when the fertility of the earth is blessed.

On one occasion, when the art community were discussing the interpretation of tribal festivals, a tribal pahan, or Shaman, visited the ashram to join the discussions. He officiated in blessing a tree and doing the puja (ritual) which is offered to the sacred tree on the feast of Karam.

Some tribal communities which have now become Christian continue to celebrate Karam but are seeking to interpret it within a Christian context. The karam tree is the central focus of the Karam festival, and it is a karam tree which is the central focus of the batik painted by these two tribal women.

"Christ is the Seed of Life," says Cecilia, and we can see that the branches of the tree form an oval-shaped seed containing Christ. His feet are held firmly to the centre of the tree, connecting him in a straight line through the heart of the tree to the earth where the roots are firmly embedded.

The male figure on the left of the tree of life is winnowing, separating the seed from the chaff, which the artists feel is man's work. On the right, the woman (in the understanding of the artists this is Mary) has swept up the seed with her broom which lies on the ground at the base of the tree and she is busy pounding the seed into food. "This is woman's work. She is making the seed into food that can be eaten." Cecilia explains that this is a sign of the Eucharist. Christ the seed, who dies on the tree, is being changed into food by the two disciples.

In the background are the houses of the people for whom Christ came, and to whom Cecilia Billung and Sebastiana Dung Dung witness through their daily life as they seek to live out their Christian faith within their own cultural reality.

- *Jyoti Sahi*

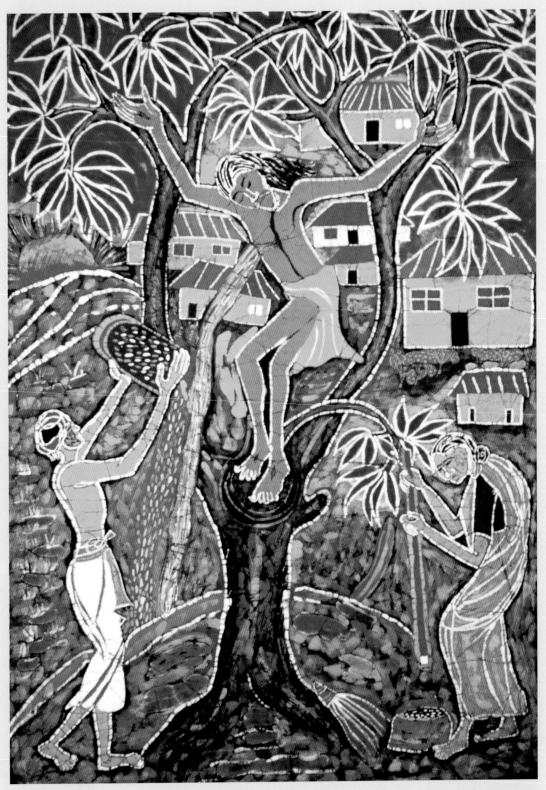

Sebastiana Dung Dung and Cecilia Billung, India, *The Tree of Life*, 1998, batik

The painting *Tree of Life* comes from the tradition of the Anishinabe people (Ojibway), one of the original tribes of North America.

The artist, Blake Debassige, says his painting is a celebration of life.

He explains that each part of the work has its own special meaning. The stylized owl, the harbinger of death, is perched on the top of the the tree as a reminder that people are mortal. Death is part of our living.

There are two representations of the Holy Trinity: the three birds sitting on the treetop and the three circles above them.

Birds are believed to be the medium by which the soul travels. Each bird represents people who have died but whose presence is still felt around us. Faces within the tree represent people of varied ages who are living today.

There are three figures on the lower branches: an animal-like form, a human form and a cocoon-shaped form. These represent the ancient culture and way of life of the people. They do not figure strongly in the mural but they are still present. Some of the ancient traditions and the language remain but there is much that has been lost.

The naked Christ is depicted as an Indian Christ, for the native peoples adopted him generations ago. He holds wild roses in his hand, recalling the practice of giving flowers when a person dies.

Two serpents appear as if through cracks and crevices in the earth. Only their head and tail are visible. They represent temptation and the spirit of evil which exist in the world. Both are grasping at small white butterflies but are unable to secure them within their grasp. Their futility is the punishment for living in the dark side of life.

The tree itself is a cedar, known for its medicinal purposes and respected by the people. It is well rooted, firmly planted and strong.

The *Tree of Life* painting occupies a central position in the Anishinabe Spiritual Center, Espanola, Ontario.

Oh Great Spirit,
whose voice I hear in the wind and whose breath gives life to everyone,
Hear me.
I come to you as one of your many children.
I am weak... I am small... I need your wisdom and your strength.
Let me walk in beauty, and may my eyes ever behold the red and purple sunsets.
Make my hands respect the things you have made and make my ears sharp
so I may hear your voice.
Make me wise, so I may understand what you have taught my people
and the lessons you have hidden in each leaf and each rock.
I ask for wisdom and strength not to be superior to my brothers,
but to be able to fight my greatest enemy, myself.
Make me ever ready to come before you with clean hands and a straight eye.
So as life fades away as a fading sunset
my spirit may come to you without shame.
- *Ojibway Prayer*

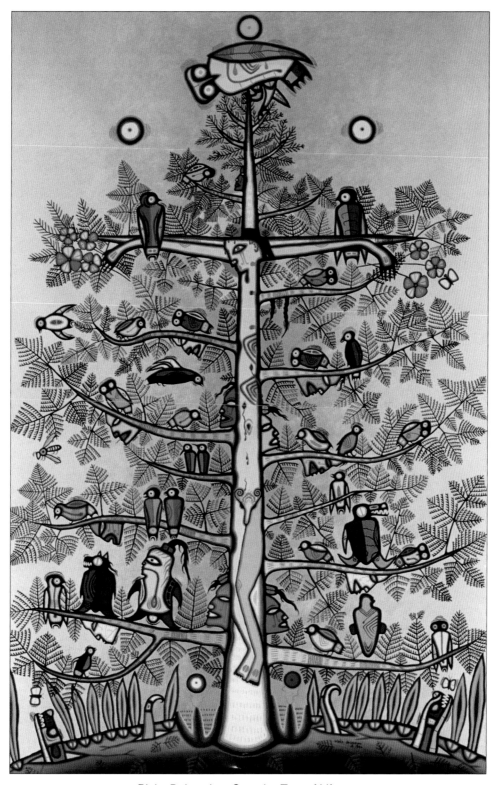

Blake Debassige, Canada, *Tree of Life,* acrylic on canvas, 244 x 155 cm

CALMING THE STORM

He (Jesus) woke up and rebuked the wind,
and said to the sea, "Peace! Be still!" (Mark 4.39)

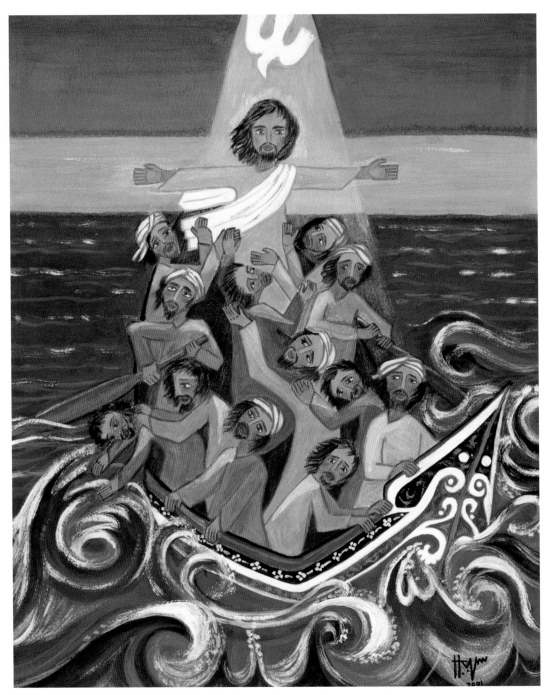

Hanna Cheriyan Varghese, Malaysia , *Peace Be Still*, 2001, –acrylic on paper 54 x 43 cm

THE MIRACULOUS DRAUGHT

Jesus said to Simon: "Put out into the deep water and let down your nets for a catch."
Simon answered, "Master, we have worked all night long but have caught nothing.
Yet if you say so, I will let down the nets."
When they had done this, they caught so many fish that
their nets were beginning to break. (Luke 5.4b-6)

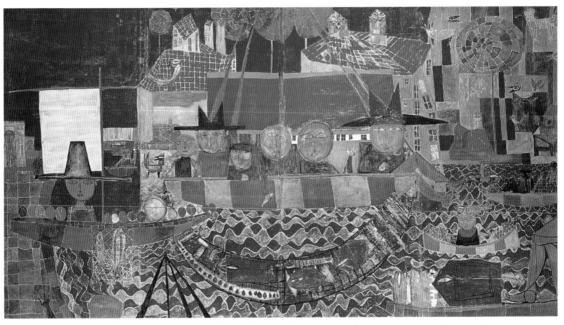

Hundertwasser and René Brô, Austria, *97 The Miraculous Draught,* 1950, chalk priming
casein on four fibre boards, each 275 x 125 cm, together 275 x 500 cm

The work of the artist is very difficult, because it cannot be done
by force, diligence or intelligence. I think that by strength and
diligence and intelligence one can do anything else in life, but the
rewards of art are totally unattainable by these means…
I believe that painting is a religious occupation, that the actual impulse
comes from without, from something else that we do not know,
an indefinable power which comes or does not come and which
guides your hand. People used to say in earlier times that it was the
muse, for example. It's a stupid thing to say of course,
but it is some kind of illumination.

- Hundertwasser

OPEN HANDS OF CHRIST

Come to me, all you that are weary and are carrying heavy burdens,
and I will give you rest. Take my yoke upon you, and learn from me;
for I am gentle and humble in heart, and you will find rest for your souls.
For my yoke is easy and my burden is light.
(Matthew 11.28-30)

Lord, take our hand and accompany us through life. Trivial and useless are we when left to our own means.

Sometimes we yearn to grasp where our road is taking us. But at some moment our trust is so total that we need neither weigh our every step nor doubt and hesitate.

We trust your promise that you would not weigh down anyone with a burden greater than they can carry. Our people have been at the mercy of foreigners and our land has been the theatre of war for centuries, but you have supported us. Give us strength to believe that even while the burden breaks us, the breakdown is also your will.

Everyone of us has a separate life. One and only one life. It does not pay to waste that life comparing our achievements with another person. Rather, we live and rejoice in what you have let us have.

We should not take freedom for granted now that Estonia has become an independent state on the world map. It has been there for a short time only and will not necessarily remain so for ever.

We ask your wisdom to remember that nothing takes us further from happiness and contentment than the desire to find either at any cost.

Really powerful are those who let the winds of success and misfortune blow over their life without leaving traces and without losing their balance. What can be more wonderful than to abide in life and death in your hands?

Sometimes we expect useless or even damaging things from you but you give to us more abundantly than we know to ask. Your mercy exceeds human understanding and is beyond what we know to wish for ourselves, our nation, or even for all humanity. It is comforting to know that your way is the best.

Deliver us from worry about the future and permit us to put our life in your hands.
 - *Toomas Paul*

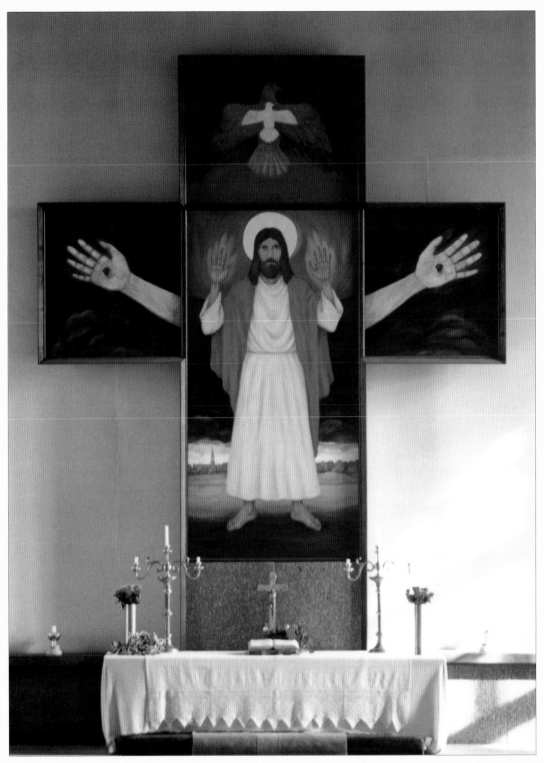

Jüri Arrak, Estonia, *Halliste Altarpiece*, 1990, oil, 700 x 375 cm

CHRIST ENTERS THE CITY

Roger Brown was born into a religious family and attended a Bible college with the intention of becoming a preacher. Instead, he became an artist and was encouraged to incorporate architectural elements into his art to strengthen it even more. All these elements of his life are seen in his work *Entry of Christ into Chicago in 1976* which was painted in that same year.

At the right Christ enters Chicago standing on the flatbed of a truck, waving and looking happy to be there - though dressed in non-contemporary clothes. The driver of the truck is also waving. One lady throws down her coat in front of the truck to welcome him, while a few other people stand on the sides of the road and at the end of the street to see and welcome him. Only a few are waving. A reviewing stand further down the street provides a platform for the mayor, the archbishop, two guitarists and four other people waiting to see him as he comes by. None appear able or willing to get down from the reviewing stand to go towards Christ to greet him.

The architecture accurately portrays some of the skyscrapers of Chicago in the background. The buildings are filled with people going about their everyday life and work. Just a few of the windows are empty, indicating that perhaps people had heard Jesus was coming and were waiting to greet him. One bridge over the Chicago River is raised. A new day is dawning.

This portrayal of Christ entering a large city is in striking contrast to earlier versions of Christ's entry into Jerusalem, such as the Coptic version on the next page. In this Coptic picture everyone is involved. One person is leading the procession with a censer swinging. One holds a processional umbrella over Christ's head. The rest of the adults are holding palms. A little child lays on an Oriental rug close to the donkey's feet and three other children climb up into a tree so they can see Christ better. Nothing in the picture detracts from the importance of the event.

In 1976 America celebrated the 200th anniversary of the American Revolution which was the beginning of a nation that professed to be founded on religious principles and practices. Whether or not this is an underlying source of satire in Roger Brown's painting (since it is dated 1976), the scene is filled with great wit and wisdom. We can uncover layers of meaning as we continue to meditate on the artist's insights and our own. Roger Brown is still the preacher.

All the elements of an important event are here but the city seems to have developed and prospered on its own without any great need for Christ's presence and power. Jesus does not appear to have any large audience excited and ready to go out to meet and welcome him. Perhaps he never will.

Jerusalem did not really do much better! It was waiting to condemn Jesus to death and have him killed. The awesome mystery is that after Jesus has risen from the dead, he keeps going back to big cities in his risen presence and tries again and again to enter them.

- John Render

Roger Brown, USA, *The Entry of Christ into Chicago in 1976*, 1976, oil on canvas, 182.9 x 304.8 cm

...they brought the donkey and the colt, and put their cloaks on them, and he
(Jesus) sat on them. A very large crowd spread their cloaks on the road,
and others cut branches from the trees and spread them on the road.
The crowds that went ahead of him and that followed were shouting,
"Hosanna to the Son of David!
Blessed is the one who comes in the name of the Lord!
Hosanna in the highest heaven!"
When he entered Jerusalem, the whole city was in turmoil, asking,
"Who is this?" The crowds were saying,
"This is the prophet Jesus from Nazareth in Galilee."
(Matthew 21.7-11)

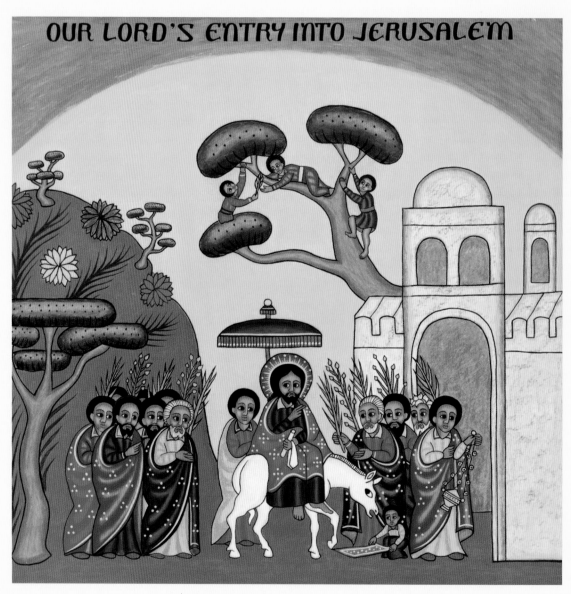

Christopher Gosey, Ethiopia, *Entry to Jerusalem*, Coptic icon, 1996, modified encaustic, 61 x 61 cm

WASHING THE DISCIPLES' FEET

After he had washed their feet, had put on his robe, and had returned
to the table, he said to the, "Do you know what I have done to you?...
I have set you an example, that you also should do as I have done to you.
Very truly, I tell you, servants are not greater than their master,
nor are messengers greater than the one who sent them."
(John 13.12,15,16)

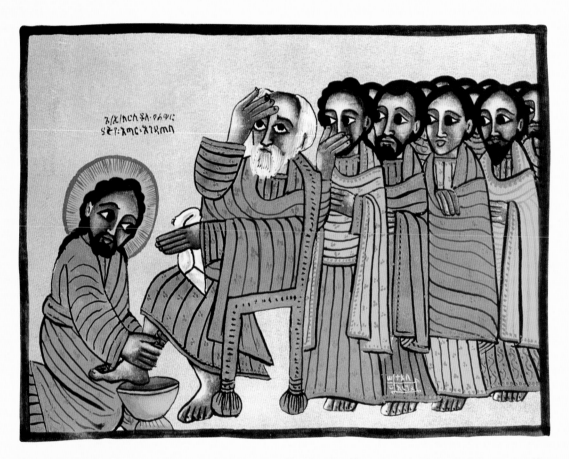

Anon, Ethiopia, *Washing the Feet*, traditional Coptic painting on goatskin

Christ washing his disciples' feet is a popular story in Ethiopia.
In traditional homes, the host still washes the dusty feet of guests.
This painting shows expressions of discomfort, embarrassment
and bewilderment on the faces of the disciples that their Lord
should undertake such a humble task.
Jesus gives them a lesson in humility.

THE LAST SUPPER

Many historical depictions of the Last Supper emphasize the presence of only twelve followers. Leonardo da Vinci's version of this event would be one of the most reproduced images in history, yet its intention was to make present the elements of the Eucharist to a small community of Dominican monks in Milan. Artists over the years have sought to do the same by presenting this meal in terms of their own context and culture.

In this painting of the Last Supper by Australian artist Margaret Ackland, we see not the neat and ordered rows of holy apostles but a chaotic crowd caught in the drama of the moment. It is evening and people lean forward into the candlelight that pools around the elements of the meal. Men, women and children gather to listen to the words of Christ.

We are drawn into the drama as we look closely at the faces of those around this table. Our initial surprise is to find we cannot discern the face of Christ except as it is reflected in the faces of his followers. These faces express a range of feelings - from a sense of peacefulness to one of deep anxiety. Other faces look out at us as we become part of the picture. It is as if we have walked in late. Some people have been distracted by our entry and ask us through their eyes why we are there.

There are faces of men, young and old, and also a considerable number of women and children. This painting reminds us that women and children are not often portrayed in images of the Last Supper, yet it seems entirely consistent with what we know about Jesus who welcomed women among his disciples and frequently blessed children.

A small child peers out at us from the right hand side of the work with an innocent gaze. The woman to the left of Jesus catches us with a look clearly more confronting and questioning. Across the table from Christ is the figure of a breast-feeding mother, symbol of sustenance and comfort, serving to amplify and make present the symbols of this meal of nourishment and hope.

The inclusion of two figures crying in silent grief is not explained. Perhaps they are doorkeepers or watchers or even angels. Perhaps they anticipate the costly sacrifice of love as they hear the words of Jesus - "this is my body".

The meal of celebration that sustains the church is one which gives birth to the fullest expression of community. It is not a place of privilege and exclusion, because it celebrates God's generous and inclusive love. This painting offers one artist's vision of what that sort of meal would look like.

- Rod Pattenden

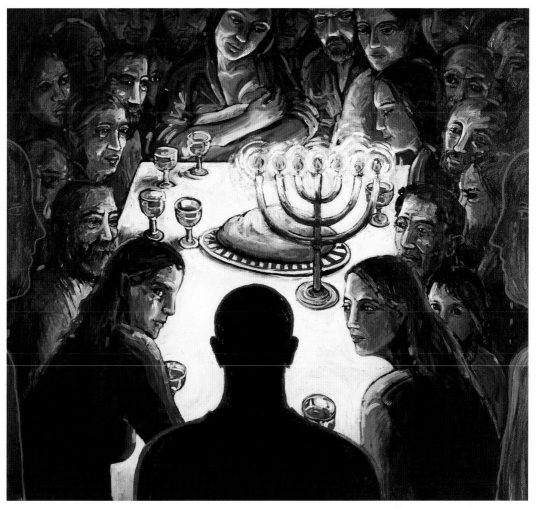

Margaret Ackland, Australia, *Last Supper*, 1993

...the Lord Jesus on the night when he was betrayed took a loaf of bread,
and when he had given thanks, he broke it and said,
"This is my body that is for you. Do this in remembrance of me."
In the same way he took the cup also, after supper, saying,
"This cup is the new covenant in my blood.
Do this, as often as you drink it, in remembrance of me."
For as often as you eat this bread and drink the cup,
you proclaim the Lord's death until he comes.
(1 Corinthians 11.23b-26)

Jorge Alexandre Rodriguez, Brazil, *The Light of Conscience*, 1999, oil on canvas, 80 x 150 cm

In *The Light of Conscience* Jesus is alone at a long table. It is one of the saddest pictures I have ever seen.

Recall what happened. The evening before he was arrested Jesus had a final meal with his disciples.

In earlier paintings of the Last Supper it was always a group of men in the picture. This reflected the no-women-allowed teaching that developed in the early church, dominated by men as the entire culture then was.

With the new millennium comes a dramatic new rendering of the Last Supper. In the Rodriquez painting there is no one else at the table with Jesus. Have they all left him? And if they have, where have they gone? Look how quiet and lonely the table is.

It is as if, 2,000 years later, the crowds have gone home. The poignant truth is that the Christianity that gave us so many Last Supper paintings has left, as a legacy, many empty churches. Two thousand years later it is as thankless as ever to be a saviour.

"Will you also go away?" Jesus once said to his close companions when things were going badly. Perhaps, the picture seems to suggest, we took him at his word.

There is another way to look at it - as a challenge to our time. Jesus is back at the table around which it all started, alone again and waiting to see who will join him for another millennium.

- Michael J. Farrell

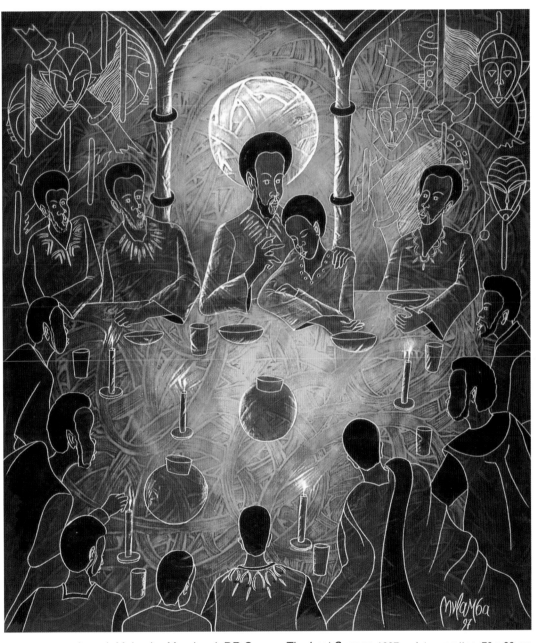

Joseph Mulamba-Mandangi, DR Congo, *The Last Supper*, 1997, peinture grattee, 70 x 60 cm
© missio Aachen, Art Calendar 1999 Africa

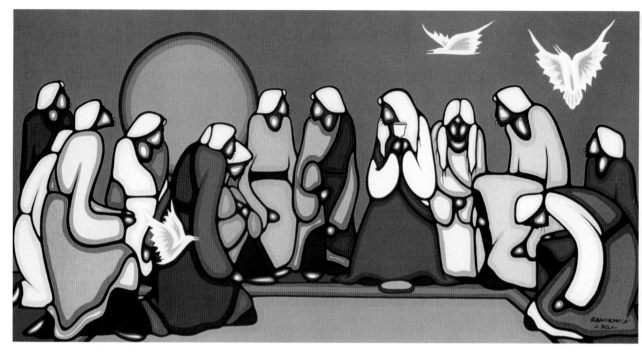

Leland Bell, Canada, *The Feast,* acrylic on canvas, 61 x 122 cm

My art comes from the Three Fires (or Midewiwin) tradition which is what I believe in. I came to this belief through a dream I had about peace. It was a deeply spiritual experience. After consulting with elders I began trying to build my sense of spirituality. I needed to have an Indian name so asked some elders to help me. I was given the name Bebaminojmat which, loosely translated, means 'when you go around you talk about good things'. Then I fasted to prepare my body and mind to talk to the Creator.

The circle is central to our tradition. The Creator sits in the East - yellow is the colour for that direction; the sacred herb is tobacco; the animal is the eagle. Red is the colour of the south - the place of all young life; the sacred plant is cedar. The west is the place of life - its colour is black; the sacred medicine is sage. Healing powers come from the North - its colour is white; sweetgrass comes from there and

that is where the sacred bear sits...

I put Jesus holding the cup of wine (in our tradition it would be water, the lifeblood of the earth) facing east where the creator resides. I see him as a healer offering life and knowledge of life to everyone in the circle.

The people at the feast are sitting in a circle, talking about life. The wavy lines at each person's lips represent the idea of how language has a power of its own; of how important it is to communicate. There is energy coming out of every person. Words move and vibrate on their own. Language is alive.

The green represents mother earth. The three birds represent the trinity - they are the messengers of this feast. The yellow floor has been purified, indicating that everything in the circle is purified. The sun represents the Grandfather, the Creator, the symbol of knowledge, kindness and comfort. - *Leland Bell*

Jesus said, "Whatever you do to the least of mine, you do to me." And I don't think there is anyone more "least" in our society today than a death row inmate. So what we do to these, we do to Christ.

Jesus himself, of course, was a death row inmate. And Jesus forgave a capital punishment prisoner with the words, "Amen, I say to you, this day you shall be with me in Paradise."

All of these things impacted this portrait of Robert Edward Williams, whom I accompanied to his death in Nebraska's electric chair on December 2, 1997.

He was 61 years old.

Twenty years earlier, under the influence of drugs and alcohol, filled with rage and self-loathing (having experienced horrible physical and sexual abuse as a child and living with poverty and racism) Robert went on a rampage, killing three women, raping two of them as well.

By the time I got to know him, he was the most God-filled person I have ever known.

I painted this particular portrait of Robert because of the incredible, serene and beautiful smile I found on his face the day after his execution. The mortician told me he had never seen such a smile on the face of a deceased person. And I remember Robert telling me that, while he was not afraid to die, he knew being

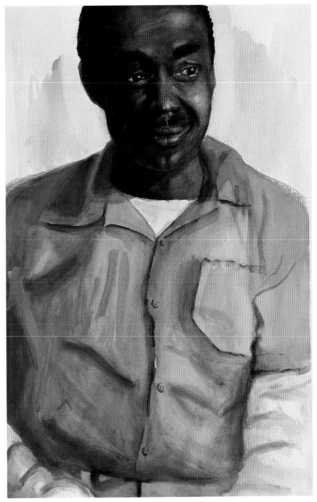

Marylyn Felion, USA, *Christ as Poor, Black, Death Row Inmate*, 1998, watercolour

strapped into the chair and waiting for the switch to be pulled would be hard. So, he said, he was just going to keep saying, "Lord, I'm coming home! Lord, I'm coming home!"

I guess that's exactly what he did.

- Marylyn Felion

Jesus said to the crowds, "Have you come out with swords and clubs
to arrest me as though I were a bandit?
Day after day I sat in the temple teaching and you did not arrest me.
But all this has taken place so that the scriptures of the prophets may be fulfilled."
Then all the disciples deserted him and fled.
(Matthew 26.55b,56)

The painting reflects bewilderment. It is bewilderment in face of the cruelty and the barbarism which have made the world into their house. The gaze reveals at the same time fear and reproach, as if to say: "You rejected the Holy and Righteous One." (Acts 3.14)

Perversity knows no limits. Life, which is holy, is worth less than the dry leaf carried by the wind.

When words no longer express anything it is up to the body, the hands and the eyes to speak of what is taking place in the anguished soul. And what do they say?

"My God, what horror. I took the bitter cup of death on the cross to reconcile the world with God, but the wounds will not heal, neither will the pain pass away, and death repeats itself day after day. Where are my friends? Where are the Lord's faithful - my hands today - who cure and save the living." (Revelation 3.2)

Still, the eyes and the hands of Christ have not yet denied his love, sweat and tears for the world. He has not hidden his face from us.

As unbelievable as it may sound, these eyes and these hands still hold a thread of hope. Not hope in the human capacity to show righteousness and solidarity but hope in the love and justice of God who wipes away tears and sweeps away sadness, death and pain as old things from the face of the earth and makes all things new. (Revelation 21.4)

The millennium would be born dead without this hope.

- *Rolfe Droste*

108

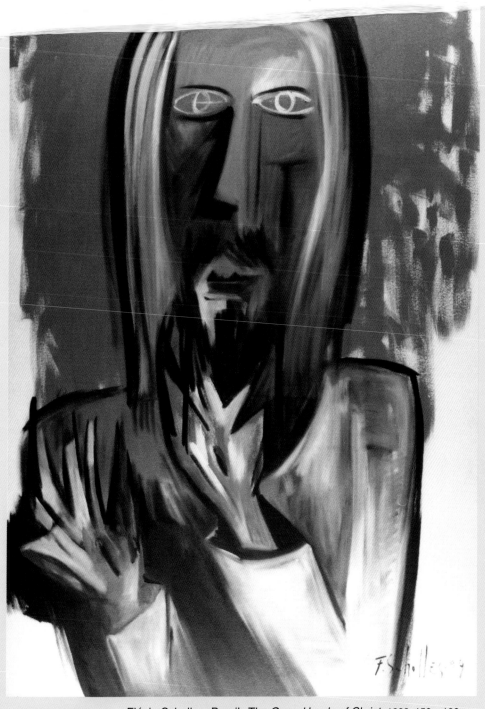

Flávio Scholles, Brazil, *The Open Hands of Christ*, 1999, 150 x 100 cm

The story happened nearly two thousand years ago. It continues to be re-enacted throughout centuries and continents. A Just One is accused and must be done away with because he disturbs the unjust order and unmasks its hypocrisy. The religious establishment of Jerusalem hand him over to Pilate. In the headquarters of the Roman procurator the representative of the military and political power of the occupying empire is confronted by the spiritual authority of Jesus. And Pilate becomes hesitant and helpless.

According to the Gospel of John, three times he tries to shift off the unjustly accused one to the Jewish leaders. Neither he nor the religious authorities want to dirty their hands and take responsibility for the juridical murder. Pilate actually washes his hands and the high priests remain outside the Roman headquarters in order not to become ritually unclean.

Exasperated, the procurator finally lets the strangely silent Jesus be flogged. His soldiers put a crown of thorns on his head, dress him in a purple robe, mock him and strike him on the face.

Thus Pilate presents him to the high priests and their officers: "See, I am bringing him out to you, that you know that I find no crime in him… Here is your man!" The answer still rings in our ears: "Crucify him!"

'Ecce Homo' - behold the true human being! By him men, women and children can learn to become truly human, growing into the persons and communities which they are called to be:

• Full of holy anger like the prophet Jesus - anger with people and structures which arrogantly exploit the poor. Yet he does not yield to the temptation of counter-violence. The love of power is overcome by the power of love.

• Full of inner strength like that of the servant Jesus - confident in the midst of enmity and hopeless situations, he knows from whence this world comes and where, through the cross, it is leading to: from God's good creation to a new heaven and a new earth

• Full of loving care like Christ the priest, committing in prayer our violent societies and its actors to God's judgment and forgiveness, trusting in the re-creating power of the Spirit.

The image of Christ before Pilate has captured the imagination of artists in every generation.

We see the quiet strength of Rouault's Christ as around him the powerful haggle about who is going to kill him. Christ stands in their midst as a focus of peace.

The Mexican artist Siqueiros, shows Jesus with outstretched, wounded hands. They are strongly interlocked in prayer, for left alone they might smash back and continue the circle of violence.

The Saviour is sculptured with a crown of thorns by an unknown artist from Haiti, eyes and mouth closed. Christ is turned inward in a silent dialogue with the One who sent him; he concentrates on the plea - "Forgive them, for they do not know what they do!"

- Hans-Reudi Weber

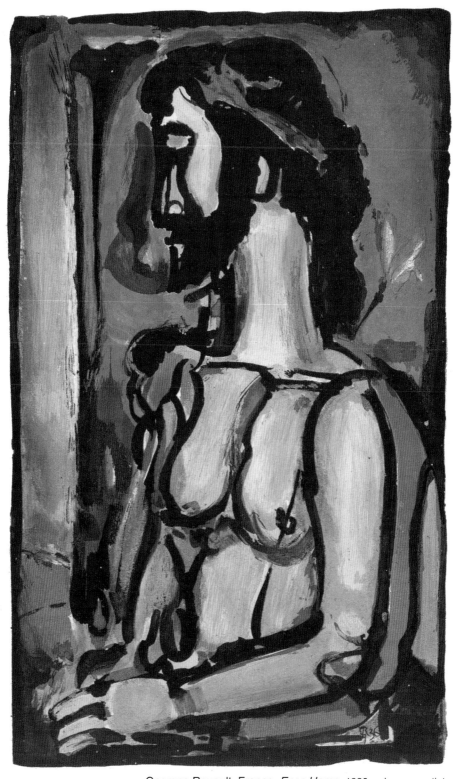

Georges Rouault, France, *Ecce Homo*, 1936, colour acquatint

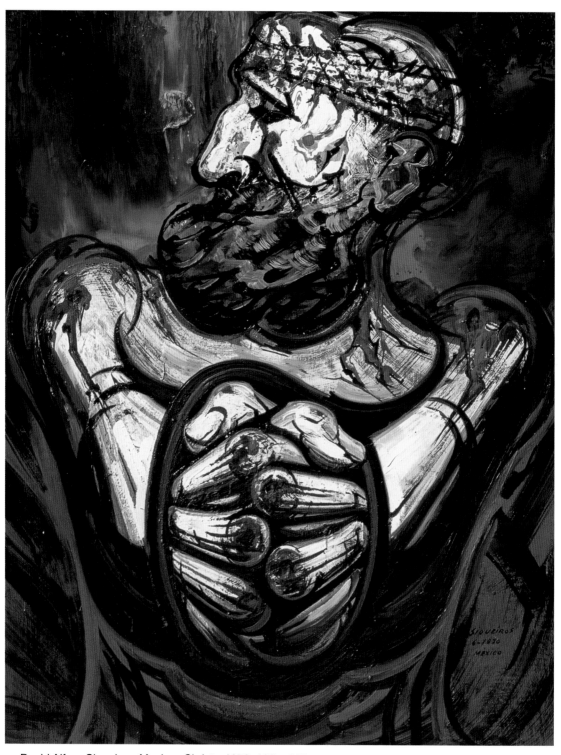

David Alfaro Siqueiros, Mexico, *Christo,* 1970, 182 x 145 cm

Anon, Haiti, *Crown of Thorns*, 1990, wood carving

Bertin Ahrin, Benin,
Stations of the Cross
bronze

Above:
Crucifixion

Left:
Carrying the Cross

Pablo Sanaguano Sanchez, Ecuador, *Via Crucis*, 1994, acrylic on canvas, 41 x 56 cm
© missio Aachen, Art Calendar 1996 Ecuador

They watched him there.
From behind their masks they watched him.
Watched him as he stumbled along, helped by a few of his friends.
He had disturbed their complacency but they were safe behind their masks.
They could look over the wall and laugh and nobody would know
what they really thought or felt. "He's a criminal", they said, "a loser".
"Six months from now, nobody will even remember this Jesus."
But in their hearts there was a vague stirring
that something was not quite as it should be.

The women of Jerusalem gathered by the side of the path they knew Jesus would take. They greeted him with cries of pain and love. They stood in the path, kneeled in the dirt and stormed the heavens with their pain-filled wailing.

Jesus, his brow streaming with blood and salty sweat, his robe soggy with the same awful mix, hears them and recovers his strength to stand. He looks at the women who had followed him, who had believed in him and continued to do so, and he is overcome.

The soldiers are dumbstruck. They know not how to counter these women, their women, their mothers, sisters and daughters, kneeling in the dust with their crying children at their feet, praising through their tears this man whom they were taking to his death. Why are they showing him such respect? He is no better than a common slave or thief, to be hung between two other thieves, the worst death possible. Who was this man whom many had condemned and yet so many others had exalted?

The women knew the truth of him. They understood the significance of his life and death. They cried but they also rejoiced that they were able to see him, to strengthen him on his way. They knew him as he knew them. They knew what Jesus told them, that the future was bleak.

"Daughters of Jerusalem, do not weep for me, but weep for yourselves and for your children. For the days are surely coming when they will say, 'Blessed are the barren and the wombs that never bore and the breasts that never nursed.'" (Luke 23.28-29)

Harsh words indeed from one about to die, but in their hearts they knew the truth of his words. Many lived to see them come to pass with the destruction of the temple and the scattering of their people.

Today we can see the truth of Jesus' words. Look at our cities and the devastation and despair present there. Look at our children - old before their time, forced to take on duties and responsibilities beyond their years. They are confronted with choices no one should have, child or adult. Should they become gang members, to find the family that no longer exists at home? Should they try drugs, or should they listen to their parents and other adults who warn them of the dangers while they themselves are smoking and drinking themselves to death?

It is not easy being a child today. Children look for certainty and guidance from the adults around them but too often find themselves victims instead. We fill our lives with so many important things that we have no time for the children with their hopes and dreams. They grow bitter and angry, foul-mouthed and profane. They have too many role models who refuse to act as such, and too few who are capable of helping them to make the right decisions in their lives.

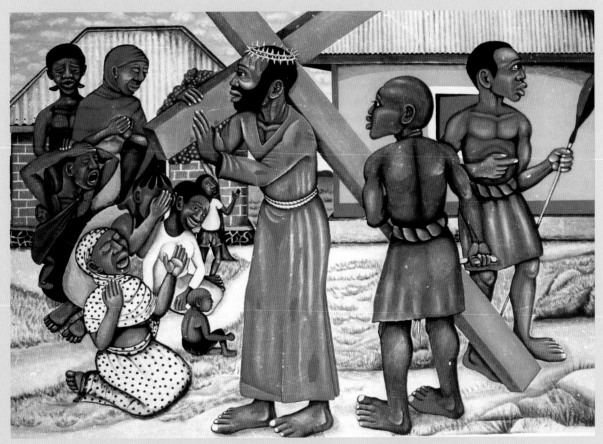

Charles S. Ndege, Tanzania, *Jesus Meets the Women of Jerusalem*, mural, c 40 x 60 cm

Children too often find themselves abandoned and alone. And women, the mothers, cry. They cry for Jesus; they cry for themselves; they cry for their children and the loss of hope.

Women bear the future in their wombs. They are the bearers of culture, the tellers of stories, the weavers of dreams. They too have fallen victim, like so many men, to the easy way out, the quick climb up the ladder of success, abandoning all they believed in along the way.

Jesus walks on to his destiny knowing that it will end in glory, the salvation for us all. We walk on as well, some quickly and surely, others stumbling and faltering, all seeking the Way, the true path of life.

Amazing grace,
How sweet the sound
That saves a wretch like me.
I once was lost
But now am found,
Was blind but now I see.

Open your eyes. See the world around us, crumbling into chaos. Draw strength from the one who gave his life so that all might live. And live!

- Diana L. Hayes

117

Ni Ketut Ayu Sri Wardani, Indonesia, *Via Dolorosa III*, 1991, oil, 110 x 90 cm

I have an impression that Christ's suffering was quite extraordinary.
I could not imagine how terrible the body of Jesus was when accepting
more than 39 lashes. All I can see is only a broken body,
full of blood and no longer smooth.
It is this reality that I try to express in my painting.
- Ni Ketut Ayu Sri Wardani

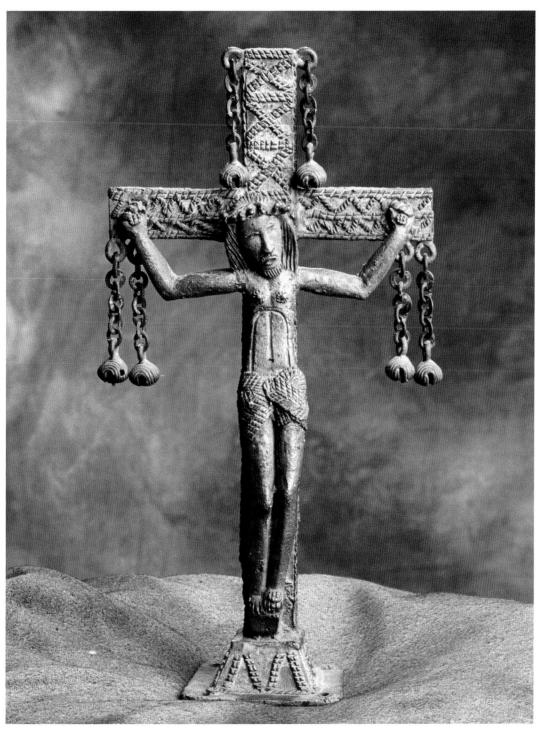

Anon, *Crucifix*, N'tboli tribe, Philippines, 1977, lost wax bronze, 25.5 cm

Owade, Botswana, *The Thorn Bush,* Forest Hill Chapel, installation

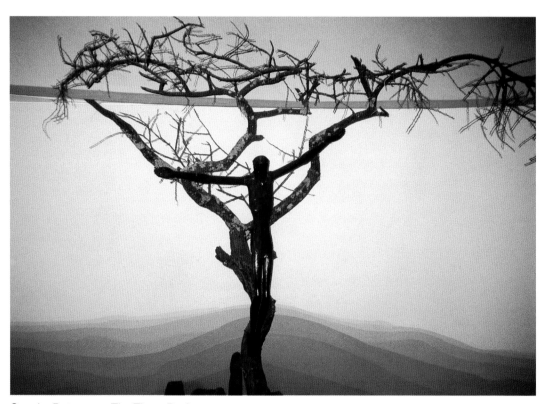

Owade, Botswana, *The Thorn Bush,* Forest Hill Chapel, installation (detail)

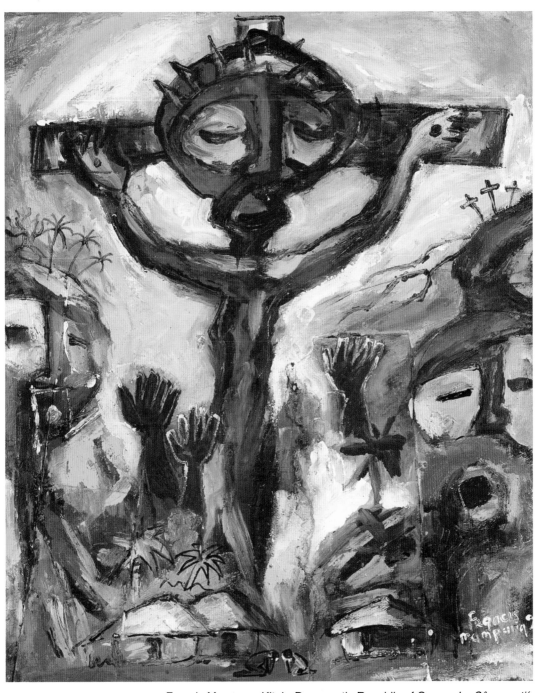

Francis Mampuya-Kitah, Democratic Republic of Congo, *La Sûprematié*
oil and acrylic on paper, collage, 53 x 46 cm, © missio Aachen, Prize painting 1997

TATTOOED CHRIST

There is a Samoan proverb which says that the Samoan culture and Christianity complement each other. One cannot survive without the other. This saying expresses the Samoans' deep love for their own culture (Fa'a Samoa) and, at the same time, their strong commitment to the Christian faith.

In this painting by Michel Tuffery, the Samoan culture and the Christian faith are brought together in a single image. It is unusual for a Samoan to see Christ tattooed but it is for me a proud image, because now I see Christ in my own culture.

The tattoo has many symbolic meanings for us. It is a long and painful process to have the tattoo done. It can take several weeks and some have died from loss of blood or from infection. It is a community action. There will always be at least two people tattooed at the same time and they will be surrounded by family and friends who encourage the ones being tattooed by singing traditional hymns and exchanging jokes.

The ceremony has much symbolism. For the men, it is a symbol of servanthood and carries responsibilities. For the women it is a symbol of royalty. For all people, the suffering of the tattoo is a call to serve the chiefs of the community and to serve God.

The kava bowl at the top of this painting is a usual accompaniment to the tattoo process. Below the figure of Christ on the cross, the two figures (female on the left and male on the right) are lying on mats. On both bodies there are the traditional tattoos of Samoa. Those on the woman (malu) are lighter in character and resemble filigree.

The artist said that having his traditional tattoo (pe'a) was the high point in his life. He described it as a spiritual experience, as if he had been reborn. This feeling is symbolized by the tradition of breaking an egg over the head of the person when the tattoo is completed.

It is a surprise for Samoans to see this painting of Christ with tattoo on his body. It suggests that Christ identifies with their culture and their suffering. There is pain and suffering in having the tattoo, but there is no greater pain and no greater suffering than the cross of Jesus.

- Tino Scanlan

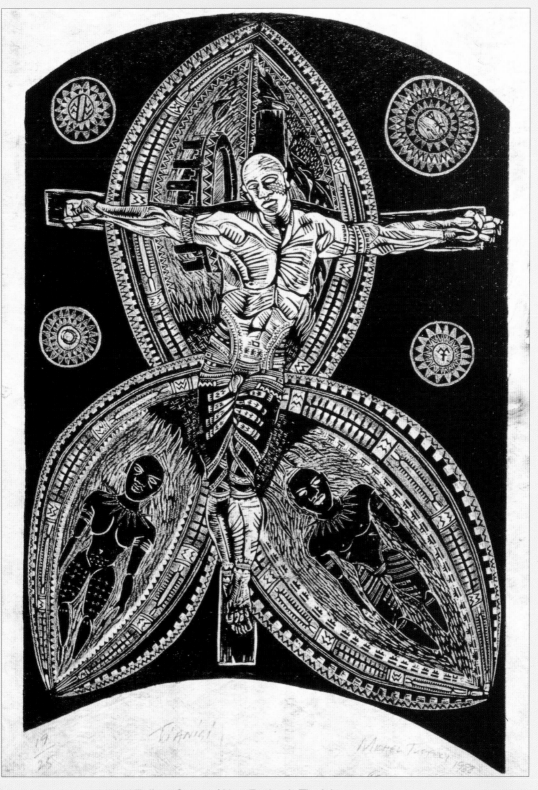

Michel Tuffery, Samoa / New Zealand, *Tianigi*, 1988, woodcut on flax paper, 76.5 x 54 cm

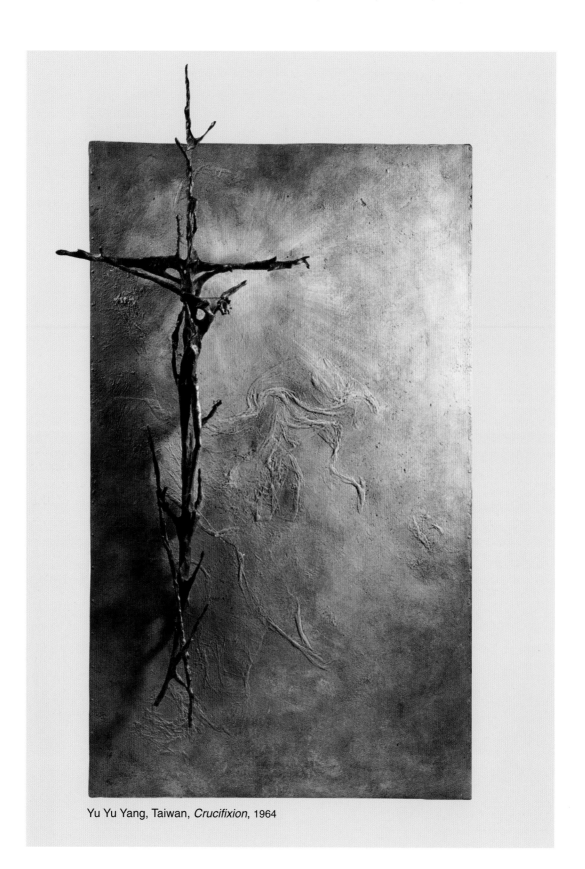

Yu Yu Yang, Taiwan, *Crucifixion*, 1964

The Swedish sculptor and painter Bror Hjorth made a serious attempt in 1940 to portray a realistic image of the crucified Christ and had to pay a considerable price for this, as he included a statement against anti-Semitism and the war at the very moment when Germany seemed to be winning the war.

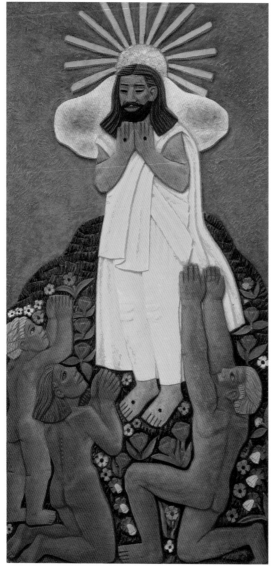

Bror Hjorth, Sweden, *The Hope*
1940, wooden relief

Who was he to present a Jewish-looking Christ? An Aryan-looking Christ was considered more truthful to tradition and piety and the common ideal of beauty inherited from classical antiquity.

Bror Hjorth entered a competition for the artistic adornment of the chapel at the Karolinska Hospital in Stockholm just as the war broke out.

On the relief (left), we see the risen Christ showing his wounds to a man, a woman and a child, representing humanity, kneeling in nakedness at his feet - just as men and women are depicted in medieval paintings when rising out of their graves on judgement day.

The Risen One is standing on a flowery hill but behind his head a cloud, reminiscent of the horrors of war, is partly covering the sun, replacing the traditional cross-halo. The intention of the artist was not to shun the atrocities of the war nor the sufferings of the patients at the hospital but to show Christ as an ultimate sign of mercy and hope.

In answer to the vehement criticism of his work, the artist made a moving confession in a newspaper in 1940:

"Making an image of Christ is a task of uttermost importance. You do not commence it without being deeply interested, and it becomes - perhaps more than anything else can possibly be - deadly serious as the work progresses. You are never permitted to put the problem aside. Day and night you resolve it deep within you."

- Elisabeth Stengård

CHRIST CRUCIFIED

In Pablo Picasso's *Crucifixion* nothing is easy and nothing is straightforward. We can recognize a few things: Jesus on the cross, nearly hidden by what may be Mary in agony; a Roman soldier on his horse piercing Jesus' side with a spear; soldiers down below casting dice on a drum. These are not depictions but merely references to other depictions we have seen before. And everything else is chaos and confusion with misshapen and misplaced body parts strewn wildly about. What is Picasso up to?

Surrealism, for one thing.

Pablo Picasso was continually experimenting with new ideas and surrealism, the artistic movement which produced fantastic imagery with unnatural juxtapositions or combinations, caught his imagination early in his career. He chose the subject of Jesus' crucifixion to carry his ideas forward.

Whatever the artist may have meant in his own mind with this painting, we today can view it and realize for ourselves the chaos and confusion we have experienced in our own lives. The crucified Christ may well be nearly hidden from us in the midst of our own scattered, stressful times, when we don't know where to turn. Perhaps that is why the artist also has a ladder reaching from our own messy world up to the cross.

"Art is not truth," said Picasso in 1923. "Art is a lie that makes us realise truth, at least the truth that is given to us to understand." But what is truth? Picasso here raises Pontius Pilate's question to Jesus on that first Good Friday. "Truth is given to us," the artist rightly says. But from whom? With Jesus and Pilate we have two clear alternative sources for truth: the one soon to be crucified and the one authorizing the execution.

Pilate facing Jesus the Christ did not realize God's own truth was right in front of him. But ultimately it did not matter to him; he did what the crowd wanted and sentenced Jesus to death. The humiliating crucifixion of their Lord must have plunged the disciples into chaos and confusion much as Picasso shows it here. But Jesus rose on the third day (is that the gravestone in the upper left corner of the painting?) and proved beyond doubt the truth of God's love and mercy for all who trust in him. Let the hidden cross be a source of comfort for you as well.

- Marie Schroeder

Pablo Picasso, Spain, *Crucifixion*, 1930, oil on plywood, 50 x 65.5 cm

Those who passed by derided him, shaking their heads and saying,
"You who would destroy the temple and build it in three days, save yourself!
If you are the Son of God, come down from the cross."
In the same way the chief priests also, along with the
scribes and elders, were mocking him, saying,
"He saved others; he cannot save himself."
(Matthew 27.39-42)

Liberation theology arose in Latin America in the final third of the twentieth century and with it came an explosion of Latin American Christian art of the same genre. One of the multitude of liberation Christian artists is Edilberto Merida of Cuzco, Peru. His crucifix of *The Tortured Christ* became known worldwide as the cover art on the English edition of *A Theology of Liberation*, the 1974 manifesto for the movement written by Gustavo Gutiérrez.

The crucifix pictured here, a later work, moves us forward from the horror of Christ's cry of dereliction - "My God, my God, why?" - toward the end of Good Friday afternoon. The closed eyes and the limp torso tell us: "It is finished. Into your hands I commend my life." The image conveys closure; not just the closure of what the world has done to its Lord but vice versa, what God's Son has done for God's world. Some scholars note that the single Greek term translated "it is finished" is technical language from jurisprudence: "case closed!"

It was finally not Jesus alone who was on trial but we to whom he was sent by God. Our relationship to Jesus closes the case for us as well - for life or for death. Though nobody escapes being part of the crowd that pushes him to the cross yet it is to us that he says: "Whoever believes in me has the life that lasts."

Can life-that-lasts flow from this lifeless one that Merida presents? The Good News is a firm "yes" to the question. Christ's huge hands and feet in this crucifix signal that. They are Merida's trademark in many of his works. Merida has seen something in the New Testament gospels: Jesus' hands and feet are an 'oversize' trademark of his own work.

Start with the feet. Throughout the gospel narratives Jesus walks on those feet into every valley of despair, into the shadow of death and finally up to Jerusalem to close the case for us. The final verdict for that closure is to guide our feet into the way of peace.

And the hands. Though impaled in that position, Jesus' hands were always open. Open and inviting. Never any clenched fists. "Come to me, all you that are weary and are carrying heavy burdens, and I will give you rest." (Matthew 11.28)

These hands blessed children, healed the blind and deaf, raised the cripples to walk again, even touched corpses and lepers to restore them to life. These are big hands! And in the final Easter episode to Thomas the same hands, now pierced, are the sign from the risen Christ that the one crucified is indeed "my Lord and my God!" In the initial gospel narratives and to all of us today these hands offer his very own self:

"Take and eat, take and drink."

These pierced hands prompt Christians to confess: He's got the whole world in his hands - both of them.

- *Edward H. Schroeder*

128

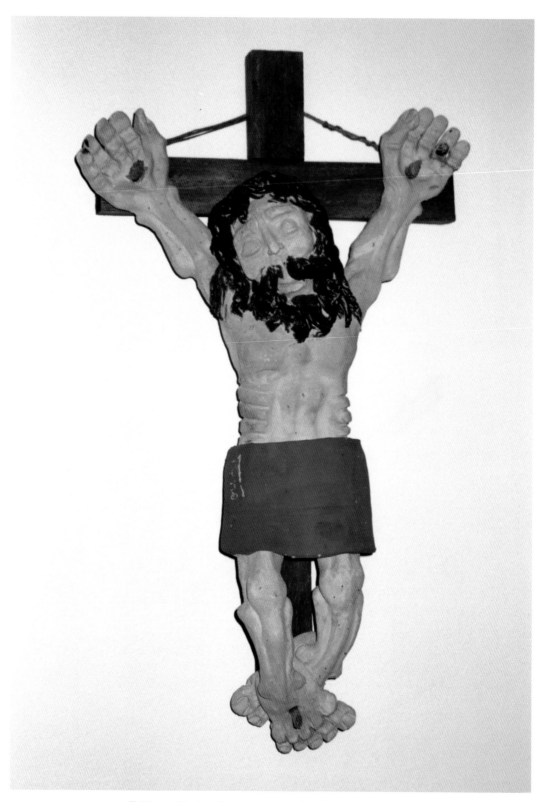

Edilberto Merida, Peru, *Jesus on the Cross,* 1996, ceramic corpus on wooden cross

*In the beginning was the Word, and the Word was with God.
He was in the beginning with God. All things came into being through
him, and without him not one thing came into being. What has come
into being in him was life, and the life was the light of all people.
The light shines in the darkness,
and the darkness did not overcome it. (John 1.1-5)*

Against the hills of New Zealand I saw a body on a cross. "It doesn't belong here," I said. "It belongs in another time and another place. It belongs in history, against the hills of Judea. It belongs in church."

I could not see it any other way.

I could not see other bodies and other crosses that *do* belong to this time and in this place. I could not see the battered child, the abused woman, the neglected old person, the teenage suicide, the hit-and-run victim, the body racked with AIDS. I could not see the first people of New Zealand, alienated from heritage and home.

I could not see *other* bodies and *other* crosses that belong to this time but in other places. I could not see the torture chambers, the mass graves, the bodies tossed into the ocean from the air, the rapists, the bombs and bullets, the machetes and landmines and knives.

I could not see the horror, the terror, the politicians' prevarication, the generals' justification, the ethnic excuse, and the religious rationale.

I could see only a body and a cross, out of time, out of place. A lamp cast light on what I was unable to see.

I drew closer and looked some more. I looked and I saw. I saw not just a body on a cross but *every* body on *every* cross of hate and rage, fear of difference and lust for power. I saw every body, from every place, in every time where brutality and madness reign. I looked and I saw humankind upon a cross, set against the hills of my country.

A body, a cross, a lamp.

I look and I remember from that time to this - from that place to this place, "the light shines in the darkness…"

I remember how that death was not an ending but a beginning, not a snuffing out but the kindling of a flame of love. It spreads through every time and to every place, even here to the end of the earth, showing every deed of darkness for what it is, "…and the darkness did not overcome it."

I looked. And now it is time to get down from my ladder, to cease from looking. It is time to fuel the flame and to embrace the loving in this time and in this and every place. It is time to overcome the darkness. — *David Clark*

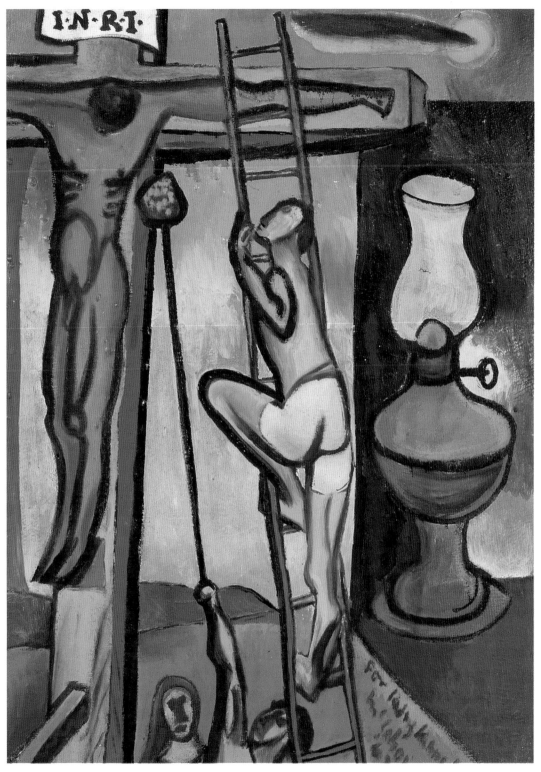

Colin McCahon, New Zealand, *Crucifixion*, 1947, oil on cheesecloth on board, 74.6 x 53.6 cm

PIETA

Not long ago, Berlin was a divided city. The wall, the watchtowers, the armed guards, the minefields dominated everything. Two great power blocs had collided in its streets leaving friends, families, a great city, and a whole nation torn apart.

The wall looked so strong, so unchallengeable. Backed by enormous military might, it seemed destined to last for centuries.

Then, on 9th November 1989, with an extraordinary push of people power, without a shot being fired, the wall and all it represented crumbled into history.

Such memories loomed large when the Central Committee of the World Council of Churches (WCC) met, in 2001, in a wall-less Berlin. A major agenda item was the WCC's new ecumenical Decade to Overcome Violence. Where better to inaugurate it than a city that knew better than most the horrors of war, amid people who had practised more than most the power of non-violence?

Local church leaders referred to the momentous change one morning during the Central Committee's worship. As they recalled…

"We were ready for anything, said the commander of the armed forces, but not prayers and candles - then suddenly, instead of running battles we had joyful celebrations in the streets. 'No violence', the slogan of a peaceful revolution. It all seemed a bit uncanny to us, because there was no stone-throwing or shooting…

"We are in a place where the word of the prophet was actually and literally fulfilled: swords into ploughshares - you can see it all around you as you walk about - a military training ground that is now the site of the national gardens exhibition; our children go to school in buildings that were once military barracks and the best mushrooms grow where medium-range missiles with multiple warheads were once stationed.

"The world says, I don't know what it means. But faith struggles to find words: Bless the Lord, O my soul, and forget not all his benefits."

A Berlin artist, whose work breathes compassion, Käthe Kollwitz knew the meaning of suffering. When her son was killed in the trenches in the first world war her art struggled with the theme of human suffering and hope. Her bronze *Pieta* sits in a little public shrine to reconciliation on the Unter den Linden, in the former eastern sector, not far from where the wall once stood.

In a world obsessed with the love of power, it points to the power of suffering love.
 - *David Gill*

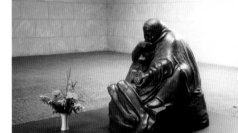

Right:
The *Pieta* sits in a small memorial chapel on Unter den Linden, Berlin where a stream of visitors and tourists remember those who suffered in two world wars.

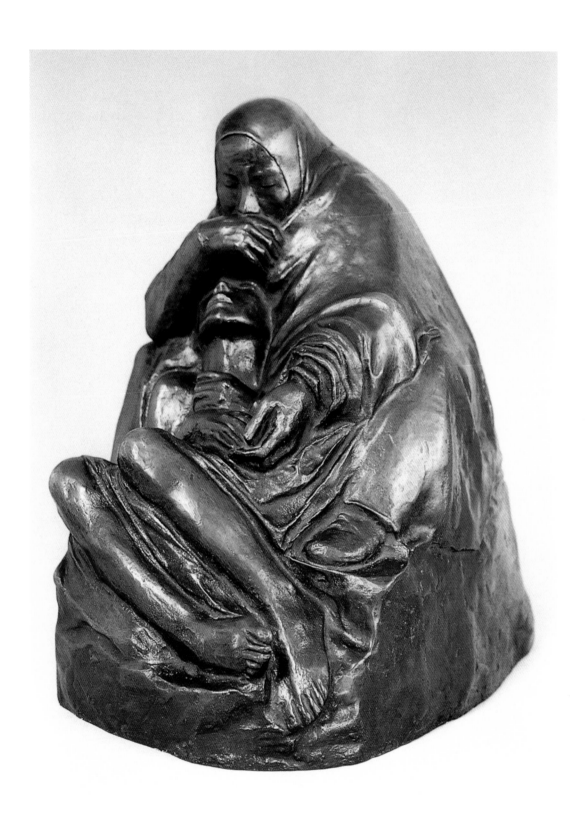

Käthe Kollwitz, Germany, *Pieta*, 1937/8, bronze

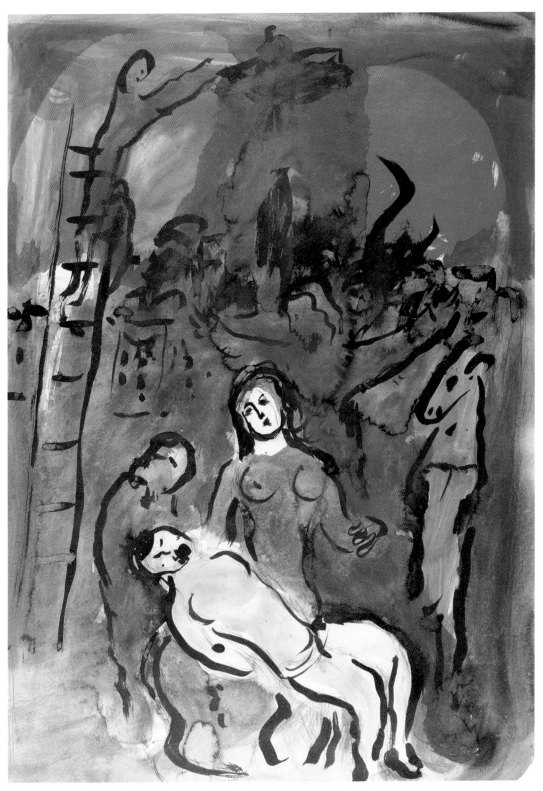

Marc Chagall, Russia / France, *Pieta (Piedad Roja)*, 1956, gouache, 77 x 55 cm

AFTER THE CROSS

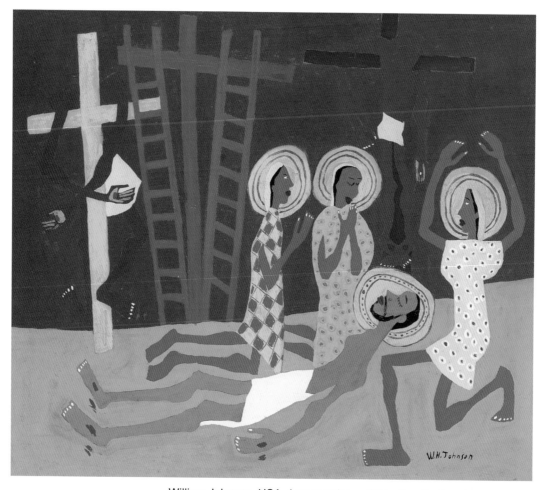

William Johnson, USA, *Lamentation*, c.1944, oil on fibreboard, 74 x 84.6 cm

Despite the troubles of our world
I have kept the love of the inner life in which I was raised
and man's hope in love. In our life there is a single colour,
as on an artist's palette, which provides the meaning of life and art.
It is the colour of love.
- *Marc Chagall*

Above: Amy Loewan, Hong Kong / Canada, *Crucifix #2*, 1999, ink, pastel, watercolour, woven strips of rice paper with text and Chinese calligraphy, 102 x 76 cms
Below: Detail of central mandala.

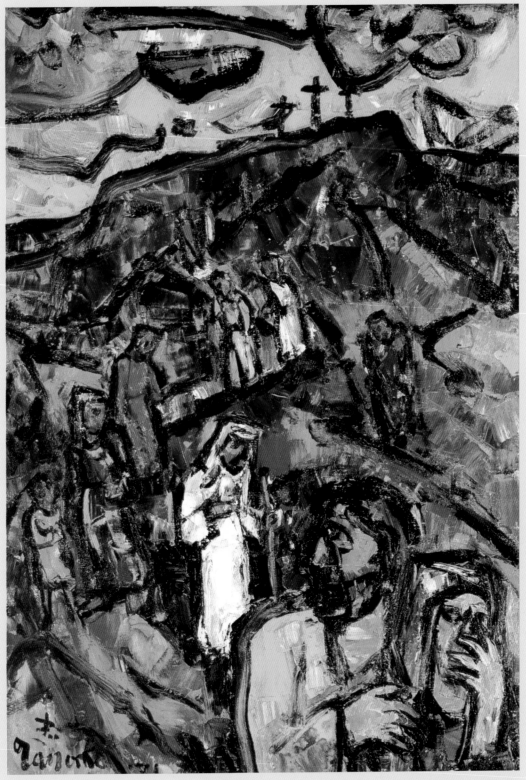

Tadao Tanaka, Japan, *People Descending the Slope*, 1971, oil

Dadirri is a special quality, a unique gift of Australian Aboriginal people. It is inner deep listening and quiet still awareness. Dadirri recognises the deep spring that is inside us. It is something similar to what is called contemplation.

The contemplative way of Dadirri spreads over our whole life. It renews us and brings us peace. It makes us feel whole again. In our Aboriginal way we learn to listen from our earliest times. We cannot live good and useful lives unless we listen.

Aboriginal people are not threatened by silence. We have been taught to be still and to wait.

We are like the tree standing in the middle of a bushfire sweeping through timber. The leaves are scorched and the tough bark is scarred and burnt but inside the tree the sap is still flowing and under the ground the roots remain strong. Like that tree we have endured the flames and we still have the power to be re-born.

Our people are used to the struggle and the long waiting. We are waiting for the white people to understand us better. We ourselves have spent many years learning about the white man's ways; we have learnt to speak the white man's language; we have listened to what he had to say. This learning and listening should go both ways. We are hoping people will come closer. We keep on longing for the things that we have always been hoping for - respect and understanding.

- Miriam-Rose Ungunmerr

Miriam-Rose Ungunmerr is an Australian aboriginal working with the church and educational groups in the Northern Territory of Australia. In 1994 she painted, *Reconciliation - People Working Together* for St Joseph's Church in the town of Katherine. She explains the symbolism in this way:

At the bottom of the painting is the fire that is at the base of the cross. The firestick, forming the upright of the cross, moves through the Eucharist represented by the yam which is the main source of food for Aboriginal people - the Eucharist being the spiritual food given to us by Christ.

The top rim of the chalice forms the transverse of the cross. The chalice is represented in the form of a pufiny, which is our traditional paper-bark container for catching water and carrying babies.

The rays at the top of the painting symbolize the resurrection of Christ. Radiating from the fire are the symbols of reconciliation as the smoke cleanses and transforms people's lives.

In the lower right hand corner, the people are more in shadow as they continue to search for Christ.

As Christ purifies all peoples by his body and blood in the Eucharist, acceptance of each other in Christ grows and reconciliation becomes a reality.

Miriam-Rose Ungunmerr, Australia, *Reconciliation,* 1994, acrylic on canvas, 150 x 170 cm

There is no longer Jew or Greek,
There is no longer slave or free,
there is no longer male and female;
for all of you are one in Christ Jesus.
(Galatians 3.28)

...in Christ, God was reconciling the world to himself.
(2 Corinthians 5.19a)

EASTER MORNING

It is the moment before dawn. The world is alert with expectation.

In darkness, a grey and rocky hillside reflects the distress of the women who are sad and anxious as they pursue their early morning task. Pressing forward in her anxiety to reach the tomb, Mary Magdalene has an eyebrow curled in pain and a line of stress from nose to mouth. Her hair is straggling at her neck and forehead. In the lobe of her ear is a tiny red earring, duplicating the mark of the nail in the hand of her Lord. She holds several blossoms of white anemone in one hand while the other is pressed against her cheek in apprehension.

The other Mary is more self-possessed; she stands more erect and her well groomed hair is piled high under her veil. One arm circles her friend's shoulder in a comforting manner while the other balances a tray with a garland of jasmine blossoms. A graceful flask holds oil for anointing and a pile of spices awaits its preserving task.

Centred between Christ and the women is a body of water and a headland of mountains. Sunrise is just breaking in lovely glowing colours behind the hills which are still blue-grey at the height of the lingering night sky. Curls of gilded clouds are winging from darkness to light. Touching the top of the painting and gracefully framing it is the slender bough of a flowering tree, symbolizing life. By its projection our eyes are led from the mourning women to the glory of hope.

Behind the women, unseen and unheeded, the light of the glory of God breaks into a bleak and despairing world. The incarnation of God in the person of Jesus of Nazareth is about to be revealed as the light of the world in the person of the risen Christ.

Outlining the head of the Lord is a nimbus halo of gilded white; his forehead is lit by direct knowledge of God's indwelling presence. Bearing a blood-red stigmata, his hand rests gently in the soft drape of his robe. Turned slightly, his face is in repose, his almond shaped eyelids half-closed and peaceful, his shoulders firmly erect.

Although refined in Indian style, his features are strong and confident. His expression is calm with strength. The glow of sunrise spreading behind the mountainous horizon is reflected from the glory of his face, glowing on the snowy folds of his garment, spreading from behind them to the edges of the veils of the women and glancing in golden glints on blossoms, bangles and tray. As yet unaware of the wonder, the women are already overtaken by the benediction of new life.

The glory of the new creation, the presence of God with us is at the moment of dawning. Soon it will be revealed to the two women. From such a moment of despair meeting hope, the good news of God's supreme love and power will soon overturn the world.

- Naomi Wray

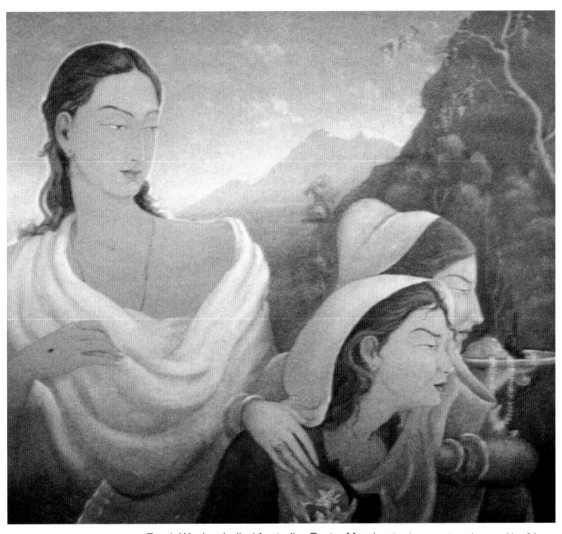

Frank Wesley, India / Australia, *Easter Morning*, Lucknow watercolour, c. 41 x 61 cm

The act of creation itself is the joy - not the end result.
What is my favourite painting? - the next one.
I draw out the ultimate joy from each work I do,
and when it is finished, I feel
both satisfied and deprived.
But I can let it go because it is no longer
a part of the urgency of the creative act.
Art is a process of being,
not a result or an achievement.
- Frank Wesley

All the people are rejoicing. Stretching their arms towards the heavens they gaze at the One who appears - almighty and larger than life; he who rises from the depths of the earth, who has conquered the darkness and has been resurrected. There is reason enough to rejoice because Jesus is in their midst. Joy encompasses them all. The shepherds have left their herds, hurrying with their crooks to the scene. Mothers with babies on their backs have joined them. There are townspeople in suits and children who run barefoot towards him.

All are standing on the edge of the abyss that has opened up - on the edge of nothing that Jesus has conquered and left behind him. Colourful life heaves its impression on this resurrection scene: yellow as the symbol of light, yellow-ochre for the radiance and joy of life, red-ochre as the colour of the savannah. The world is dried up, and rocky. It is the world in which the people live. There where Jesus rises this dry and rocky land has divided, opening to reveal the One who is light. Christ's body reveals the wounds on his hands and feet and his blood-smeared side, but his face shows no lamenting. He has overcome all pain.

His death, like his resurrection, did not happen in secret but in the midst of the people. All eyes are looking in his direction. The people have eyes and ears for him alone, eager to hear his message of life. They have no mouths, as if their amazement has made them speechless - speechless with astonishment at hearing his words "Peace be with you." (John 20.21-26) This is his message.

Peace be with you, says he who is suspended between heaven and earth. He glances directly forward, looking beyond, not only at the present situation. He stretches out his hand and shows the direction. He goes on - forward, not downwards. Death is not final. Through death we advance towards the light. It is because of this that we can have peace and tranquillity in our hearts.

We do not need to be afraid. There is another life, a life that can overcome everything - all poverty, sickness, disputes of civil war, corruption and oppression, and lack of love between neighbours.

We need not fear to go with God into a new life, travelling with him through the darkness into the light. We have every reason to rejoice.

Easter Sunday follows Good Friday. Hallelujah! - *Ingelore Haepp*

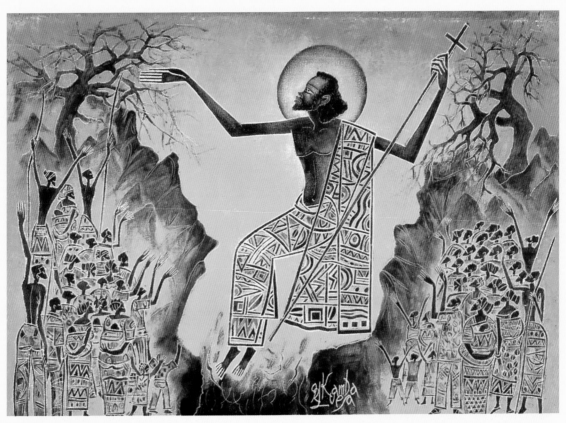

André Kamba Luesa, Zaire / D-R Congo, *Resurrection*, 1992, peinture grattée, 45 x 58 cm
© missio Aachen, Art calendar 1994, Zaire

Jesus cried again with a loud voice and breathed his last.
At that moment the curtain of the temple was torn in two,
from top to bottom.
The earth shook, and the rocks were split.
(Matthew 27.50,51)

MEAL AT EMMAUS

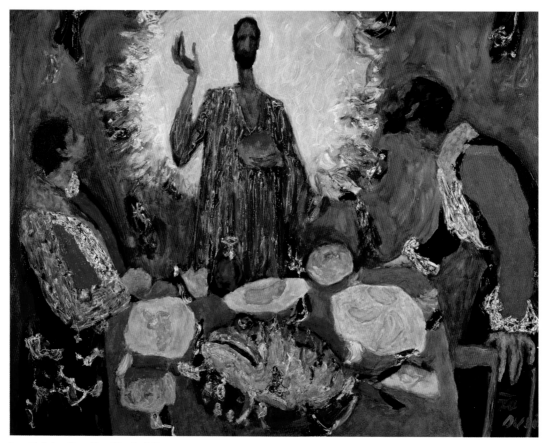

Ivo Dulcic, Croatia, *Meal at Emmaus*, 1971, oil, 80 x 108 cm

As they were near the village to which they were going,
he walked ahead as if he were going on. But they urged him strongly, saying,
"Stay with us, because it is almost evening and the day is now nearly over."
So he went in to stay with them. When he was at the table with them,
he took bread, blessed and broke it, and gave it to them.
Then their eyes were opened, and they recognized him;
and he vanished from their sight.
(Luke 24.28-31)

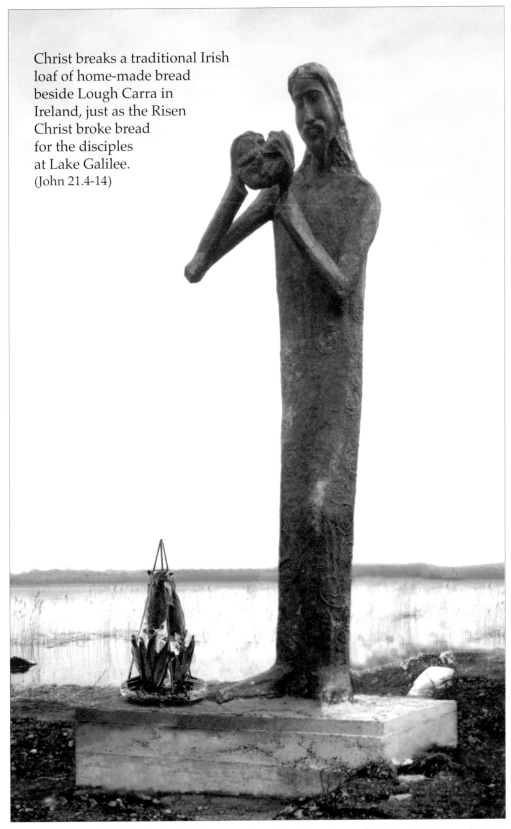

Christ breaks a traditional Irish
loaf of home-made bread
beside Lough Carra in
Ireland, just as the Risen
Christ broke bread
for the disciples
at Lake Galilee.
(John 21.4-14)

Joseph McNally, Ireland / Singapore, *The Breaking of Bread*, 2001, welded copper-bronze,
glass slabs, halogen lights, height 6.1 metres

THE LAST JUDGEMENT

Why wait for the last judgment
When living is like hell
I wish the sun will not set
And the moon never rise up
The men will come in busloads
looking for young girls for fun
I put red lipstick on
and smile when their fingers touch

Last night the soldiers came
And raided my small vineyard
I begged them to spare the tree
Grandpa planted as a boy
My baby screamed all night
The dogs lying in blood

What do I see through the bars
stars and parting clouds
I finally fell asleep
under the blankets with bugs
My rice is mixed with sand
Freedom is seasoned with salt

I wish to take the last gasp
And see this world no more
The pain will not go away
My T-cells down to forty-four
The priests searched for prayers
The drugs ran their course

I went to the shanty town
And saw him on the cross
I wanted to touch his garment
And kiss his broken feet
He is one of us
The long suffering minjung*
The phoenix will rise again
The condor with a new song
 - Kwok Pui-lan

* the ordinary people (Korean)

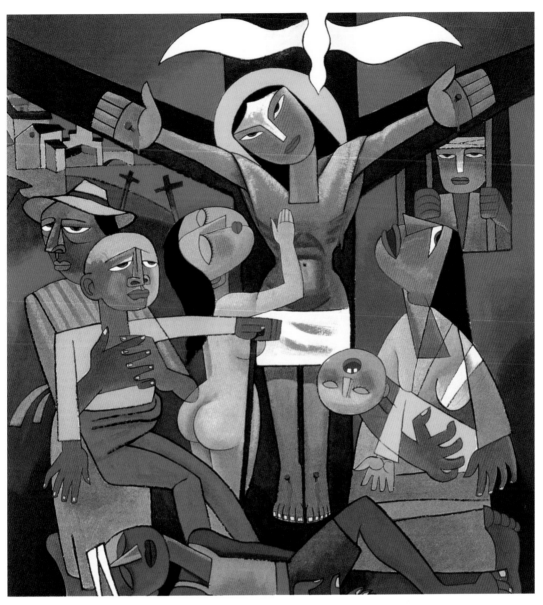

He Qi, China, *The Crucifixion (Last Judgement)*, 1999, ink and colour on paper, 101.5 x 93 cm

(Jesus said) 'Come, you that are blessed by my Father,
inherit the kingdom prepared for you from the foundation of the world;
for I was hungry and you gave me food, I was thirsty
and you gave me something to drink, I was a stranger
and you welcomed me, I was naked and you gave me clothing,
I was sick and you took care of me, I was in prison and you visited me.'
(Matthew 25.34b-36)

If people of earlier times needed sacred art to teach them their Bible today's people, so deprived of anything spiritual, need sacred art to visibly assure them of the spiritual reality. Through it, the highest forms of theology, hard to understand, are not only understood but also loved and not only loved but they also come alive. The huge mural of *The Resurrection Trilogy* at Holy Cross Mausoleum in Culver City in the United States, is an example of this spirit.

In the center of the composition stands the gigantic Risen Christ (four times life-size) dressed in flames embracing victoriously all things and filling all things with himself and his glory. He is emerging from the super-energetic tomb in which the new life of cosmic creation is born. An outburst of light in circular form embraces the whole composition.

The universal descent of Christ is seen on the left side of the composition and the right side brings his ascent into heaven. Both the descent and the ascent are totally absorbed into the all-consuming act of the resurrection.

As the Christ of the descent opens the many gates of Sheol we see the universal gate of hope with Noah and his son Shem emerging from a rainbow and the waters. The hand of Noah is holding grapes symbolizing the oncoming of the Eucharistic vine; the hands of Shem are submerged in the waters of the deluge, which also hints towards the universal waters of baptism.

Above the gate of hope is the gate of faith with Abraham and Isaac appearing out of a giant dagger. Isaac looks as if he is being crucified on the arm of the dagger, symbolizing Christ's death on the cross. Above Abraham is a large ladder of light enveloped by the body of Jacob. His hands are reaching into the heart of the descending Christ. It is here that Christ opens the universal gate of charity. Standing in this gate and emerging from a harp and a crown is David.

As our eyes follow the gesture of the hand of the descending Christ, Moses steps out from two stone tablets, opening the gate of the law. Above Moses, Ruth stands in the open gate of the Gentiles alongside the Eucharistic symbol of wheat. Above Ruth the mural shows Christ as the Cosmic Christ, Lord of the universal creation.

On the right are the figures of Adam and Eve, symbolizing matter-spirit creation and the concept of general resurrection, as they are pulled upward by the power of the resurrection of Christ.

On the far right, circling the figure of the ascending Christ, is the purely spiritual creation of God, the angels. Below the feet of Christ, the earth globe, stars, galaxies, quasars, the subatomic world and abstract spiritual hands are swirling upwards together. The ascending Christ fashions the entire universal creation without division, into a new creation.

- Isabel Piczek

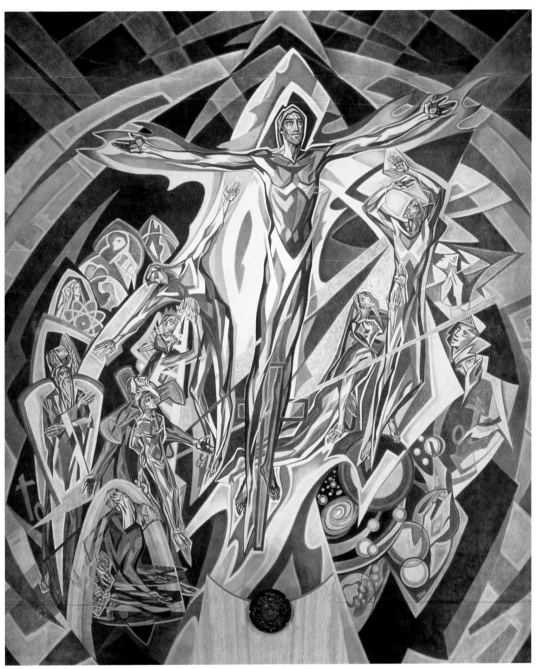

Isabel Piczek, Hungary / USA, *The Resurrection Trilogy*, acrylic, mural, 93 sq metres

Our journey draws to a close.

This book began by taking us through the centuries, from the first Christian artists in the catacombs to those at the close of the 20th century.

From there we embarked on a second journey. We followed Christ, from the time his birth was announced to his death and resurrection and saw it all through the eyes of modern Christian artists.

It is a journey which pilgrims have been making for centuries. But today the journey has taken on a new dimension. With the benefit of modern communication, we can draw on the resources of Christians in every part of the world to walk with us on our travels.

We discover that Christ wears many garments and speaks a variety of different languages. In the pages of this book you see him in the villages of Nicaragua and on the streets of Chicago. He is a black man from Benin bearing the cross and an Indonesian fisherman on the beach talking to his disciples. He is every man and every woman and is at home in every place.

We have captured intimate glimpses of Christ during our journey. Artists have the unique ability to absorb the mood of a moment and to express it through their artworks. The stark simplicity of van de Woestyne's *Christ in the Desert* (p.61), the strength of the Samaritan woman's body language in Yu Jiade's painting (p.71), the sparkling *Tree of Life* works, painted by Native Americans and Tribal Indians, (p.91-93). The eyes and hands of Jesus, and the way they are used and portrayed by modern artists, is a study in itself.

As our journey reaches its final goal, it is appropriate that the last section of this book should challenge us with artworks of immense size and majesty. The towering copper and bronze sculpture designed by Irish Singaporean Brother Joseph McNally, shows the Risen Christ standing eight metres tall above an Irish lake (p.145).

On the previous page, Isabel Piczek's enormous 1000 sq. ft tapestry soars high into the church as part of her *Resurrection Trilogy*.

Big is not always beautiful but it has been the case throughout history that many Christian artists have been overwhelmed with the sheer wonder of the cosmic triumph of Christ. They struggle to find a medium large enough or grand enough to convey the breadth and power of God's love and Christ's redemption.

Anyone who has stood for a while in the Sistine Chapel in Vatican City, with Michelangelo's art on all sides, will have some understanding of the passion which has overwhelmed Christian artists over the past 2,000 years.

The complex patterns and strong texture of tapestries may be an appropriate modern medium to convey this sense of awe and wonder.

The final art work is by Else Marie Jakobsen of Norway. In her dramatic eight metre high tapestry we see the triumphant Christ who has moved from darkness to light and from the crown of thorns to the crown of victory.

Our journey ends where it began.

With a strong affirmation that Jesus of Nazareth is the Christ for all people.

- Ron O'Grady

Right: Else Marie Jakobsen, Norway, *From Darkness to Light, From Crown of Thorns to Crown of Victory*, tapestry, 8m. high

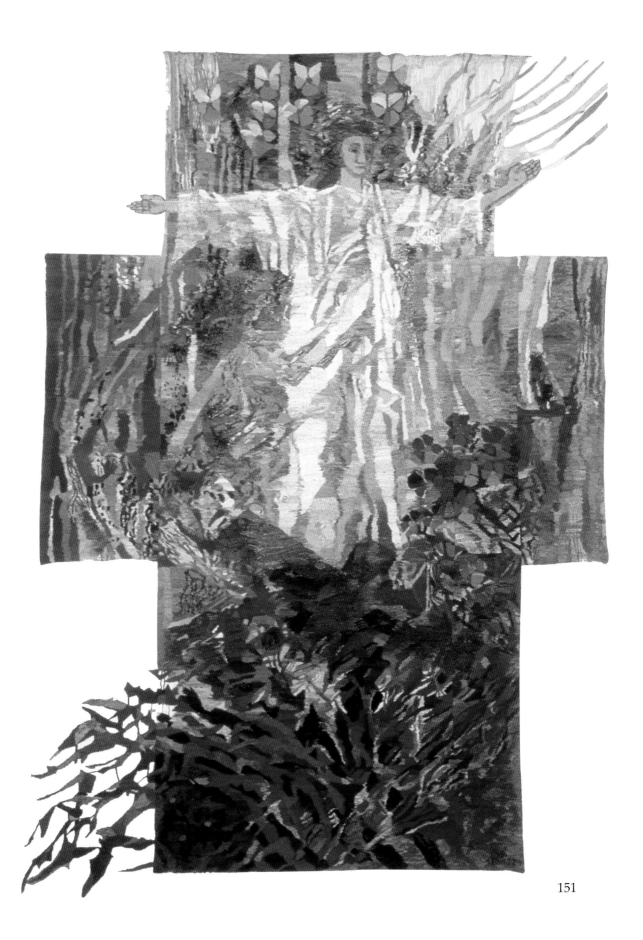

Jesus said:

"It is done!
I am Alpha and Omega,
The beginning and the end."

(Revelation 21:6a)

ACKNOWLEDGMENTS

The editors and publishers wish to thank the following who have kindly given permission to reproduce the illustrations on the pages indicated:

9 World Council of Churches, Geneva, Switzerland; **10** Bridgeman Art Library, London, UK; **11** Bridgeman Art Library, London, Lateran Museum, Rome, Italy; **12** Bridgeman Art Library, London, UK; **13** Bridgeman Art Library, London, Sant' Apollinare Nuovo, Ravenna, Italy; **15** Bridgeman Art Library, London, State Russian Museum, St Petersburg, Russia; **16** Bridgeman Art Library, London, Museo Episcopal de Vic, Osona, Catalonia, Spain; **17** Bridgeman Art Library, London, Board of Trinity College, Dublin, Ireland; **19** Bridgeman Art Library, New York, USA; **20** Bridgeman Art Library, London, Gemaldegalerie, Dresden, Germany; **21** Bridgeman Art Library, London, Vatican Museum & Galleries, Rome, Italy; **22** Bridgeman Art Library, London; **29** Bridgeman Art Library, London, Musee d'Unterlinden, Colmar, France; **14,24,25,113,120** Collection Passionist Research Center, Chicago, USA; **23** Collection John England, Christchurch, NZ; **31** Janet McKenzie 1st place winner in the National Catholic Reporter Jesus 2000 collection; **33,41, 79,105,115,121,143** Missio Aachen; **35,59,112,134,144** Vatican Museum, Collection of Modern Religious Art; **36,72,114** Galleria D'Arte Contemporanea, Pro Civitate Christiana, Assisi; **37** Mua Mission, Malawi; **39** Fernando Arizti; **40** Iosefa Leo Tupuanui; **43** Sawai Chinnawong; **44** Nalini Jayasuriya; **45** Stony Point Center, New York; **47** Bonny Ntshalintshali; **49** Yasuo Ueno; **51** John Solowianiuk; **53** Elizabeth Chan; **55** Zaki Baboun; **56** Asian Christian Art Association; **57** Collection Museum Sztuki, Lodz, Poland; **58** Hany Sameer; **61** Collection Museum of Fine Arts, Ghent, Belgium; **61,62,111,127,133,136** ©Viscopy Ltd, Australia; **62** Collection Art Gallery of Western Australia; **63** Napoleon Abueva; **64** Lawrence Sinha; **65** Asian Christian Art Association; **67** Bagong Kussudiardja; **68** Kim Jae Im; **69** Ketut Lasia; **71** Yu Jiade; **73** Lee Myung Ui; **75** Alphonso Doss; **76** Collection National Gallery of Prague; **77** Joseph Scott; **78** Peter Hammer Verlag, Germany; **81** Yoko Makoshi; **82** Than Oo; **83** Hong Chong Myung; **84** Ng Eng Teng; **85** Seiger Köder; **86** Fan Pu; **87** Private Collection, Photogaph c/o Museum of NZ, Te Papa Tongarewa, Wellington; **89** Sandra Ikse; **91** Sebastiana Dung Dung & Cecilia Billung; **93** Blake Debassige, Anishinabe Center; **94** Hanna Cheriyan Varghese; **95** © 2000 Harel, Vienna; **97** Jüri Arrak; **99** Collection of Whitney Museum of American Art, New York, USA; **100** Christopher Gosey; **101** Collection Netherlands Missionary Council; **103** Collection Assembly of the Uniting Church in Australia; **104** Jorge Rodriguez from the National Catholic Reporter Jesus 2000 collection; **106** Leland Bell, Anishinabe Center; **107** Marylyn Felion from the National Catholic Reporter Jesus 2000 collection.; **109** Flávio Scholles; **111** Collection of Museum of NZ, Te Papa Tongarewa, Wellington, NZ; **113** Collection Tim & Jean Unsworth; **117** Orbis Books, New York; **118** Ni Ketut Ayu Sri Wardani; **123** Michel Tuffery; **124** Yu Yu Yang; **125** Bjorn Hort; **129** Collection M. Schroeder; **131** Collection Jennifer B. Gibbs, Auckland NZ; **135** Smithsonian American Art Museum, Washington DC/Art Resource NY; **136** Amy Leuwan; **137** Estate Tadao Tanaka; **139** Merrepen Arts - Nauiyu, Australia; **141** Frank Wesley; **145** Joseph McNally; **147** He Qi; **149** Isabel Piczek; **151** Else Marie Jakobsen.

Thanks to publishers for permission to quote from the following publications:
22 Eric Newton, *The Christian Faith in Art,* Thames & Hudson,1966; **34** Kyung C.H., *Struggle to be the Sun Again*, Orbis Books, NY, 1990; **46** Desmond Tutu, introduction to Gavin Younge, *Art of the African Townships*, Thames & Hudson, 1988; **48** *Christmas Letter 2000,* International Center of Bethlehem; **66** Eka Darmaputera, *Many Faces of Christian Art in Indonesia*, PGI, Jakarta, 1993; **74** *Image (Sept. 83),* magazine of Asian Christian Art Association; **116** Hayes, Diana L., *Were You There?* Orbis Books, NY, 2000.

WRITERS